the Adventures of HUGH JORGAN

CREATED BY ROCK HARDING

This book, both in its entirety and in portions is the sole property of

TPS PUBLISHING

Copyright © April 2017 by TPS Publishing

2017 PRINT EDITION

ISBN-13: 978-1-365-90218-5 ~ Lulu Print Distributions

No part of this book may be reproduced, scanned, uploaded or distributed via the Internet or any other means, electronic or print, without permission from the TPS Publishing or the artist Rock Harding. Warning: The unauthorized reproduction or distribution of this copyrighted work is illegal. Criminal copyright infringement, including infringement without monetary gain, is investigated by the FBI and is punishable by up to 5 years in federal prison and a fine of $250,000. (http://www.fbi.gov/ipr/). Please purchase only authorized electronic or print editions and do not participate in or encourage the electronic piracy of copyrighted material. Your support of the author's rights and livelihood is appreciated.

All artwork is a combined work of stock images, sketches and photoshop art of Rock Harding
Book & Page Formatting: TPS Publishing
Cover Art: TPS Publishing
Stock Images purchased from: Shutterstock, 123F, and Fotolia

ALL ABOUT HUGH JORGAN

Hugh Jorgan, when standing erect, is a clean cut nine and three-quarter inches tall and just a smidgen shay of two inches wide.

He considers himself exceptionally fit, hitting the local gym, called "The Hole" at least three to four times a week. When he's not pumping up, he spends his time watching his Master shave and eagerly awaits the results of any evening flirting. He also enjoys hanging out with his best buddy, Lefty, and occasionally plays submissive to Sir Right.

Hugh is a proud and Out Bi-Sexual, finding both men and women a loving pleasure to be inside. And he's just about up for almost anything. If he isn't, just give him a bit of ego stroking and he'll be up and ready in no time.

It's this adventurous life that has led to this coloring book, so he hopes you enjoy the fun as much as he did.

WARNING

This coloring book contains images and wording expressed scrictly for Adult Entertainment (18+ only) which may be considered offensive to some readers. It is intended for sales and the entertainment to adults ONLY, as defined by the laws of the country in which you made your purchase. It is not work safe or family viewing safe, so please store your coloring book in a safe place and way from reach of young kids.

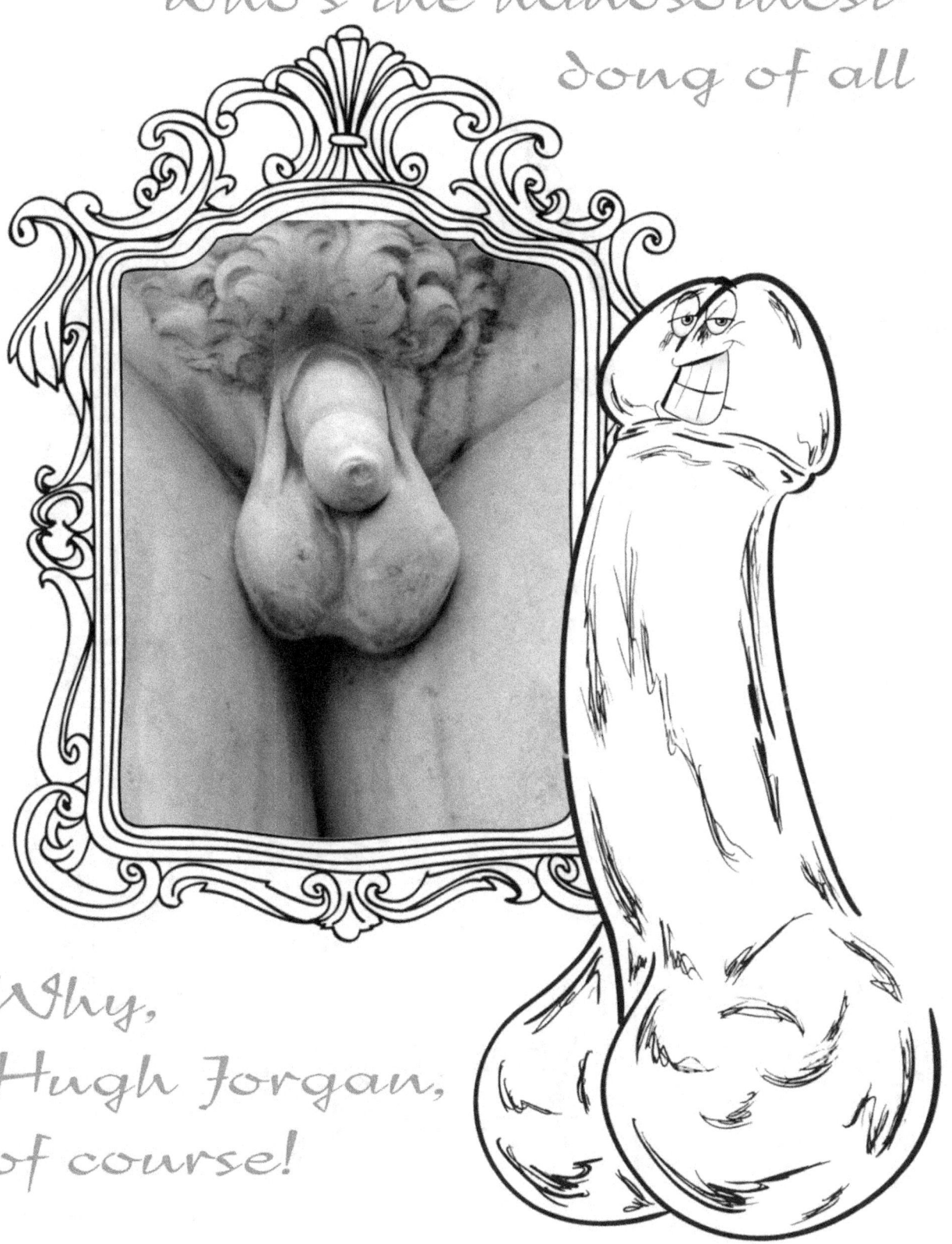

Mirror, Mirror, on the wall, who's the handsomest dong of all

Why, Hugh Jorgan, of course!

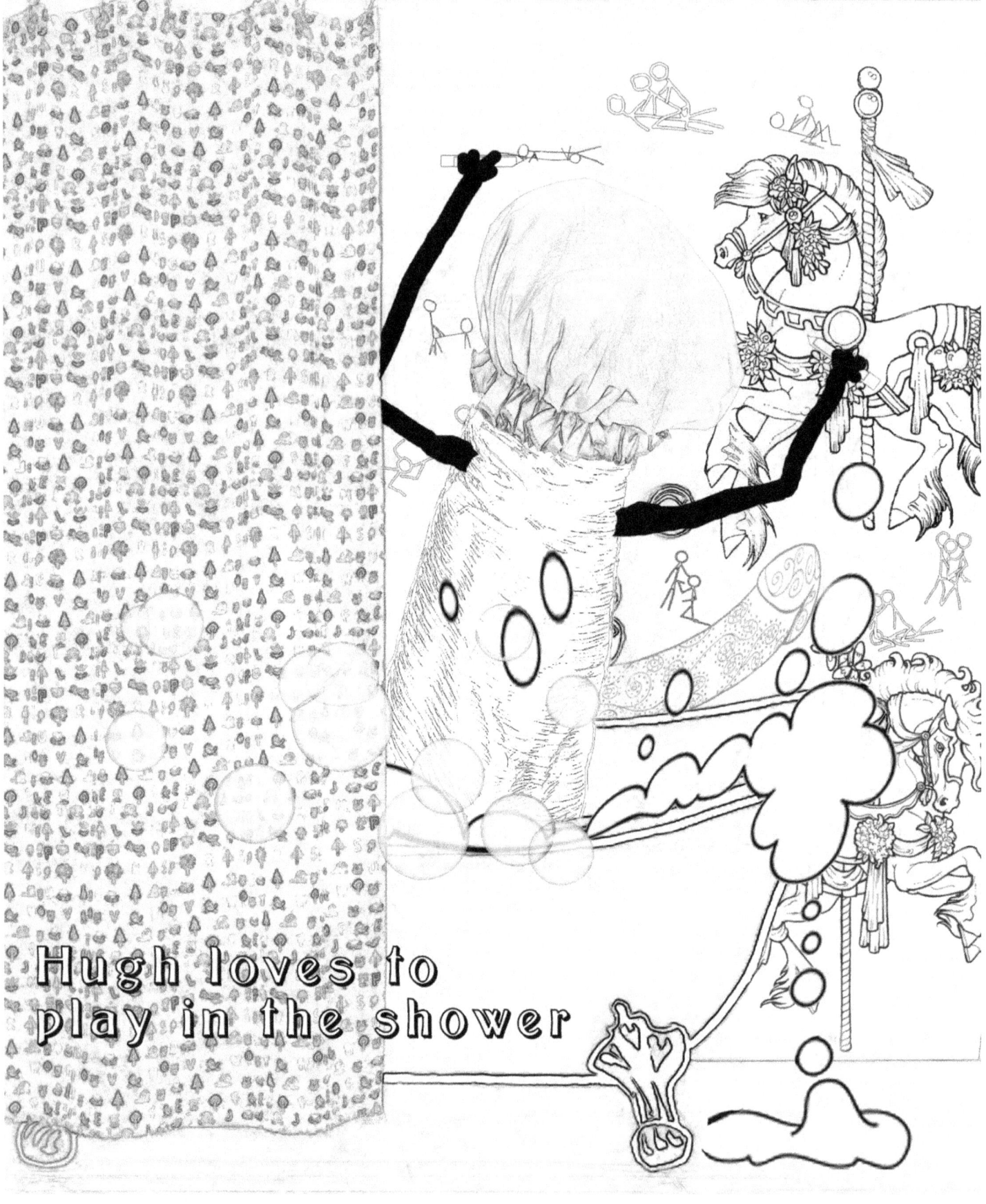

Hugh loves to play in the shower

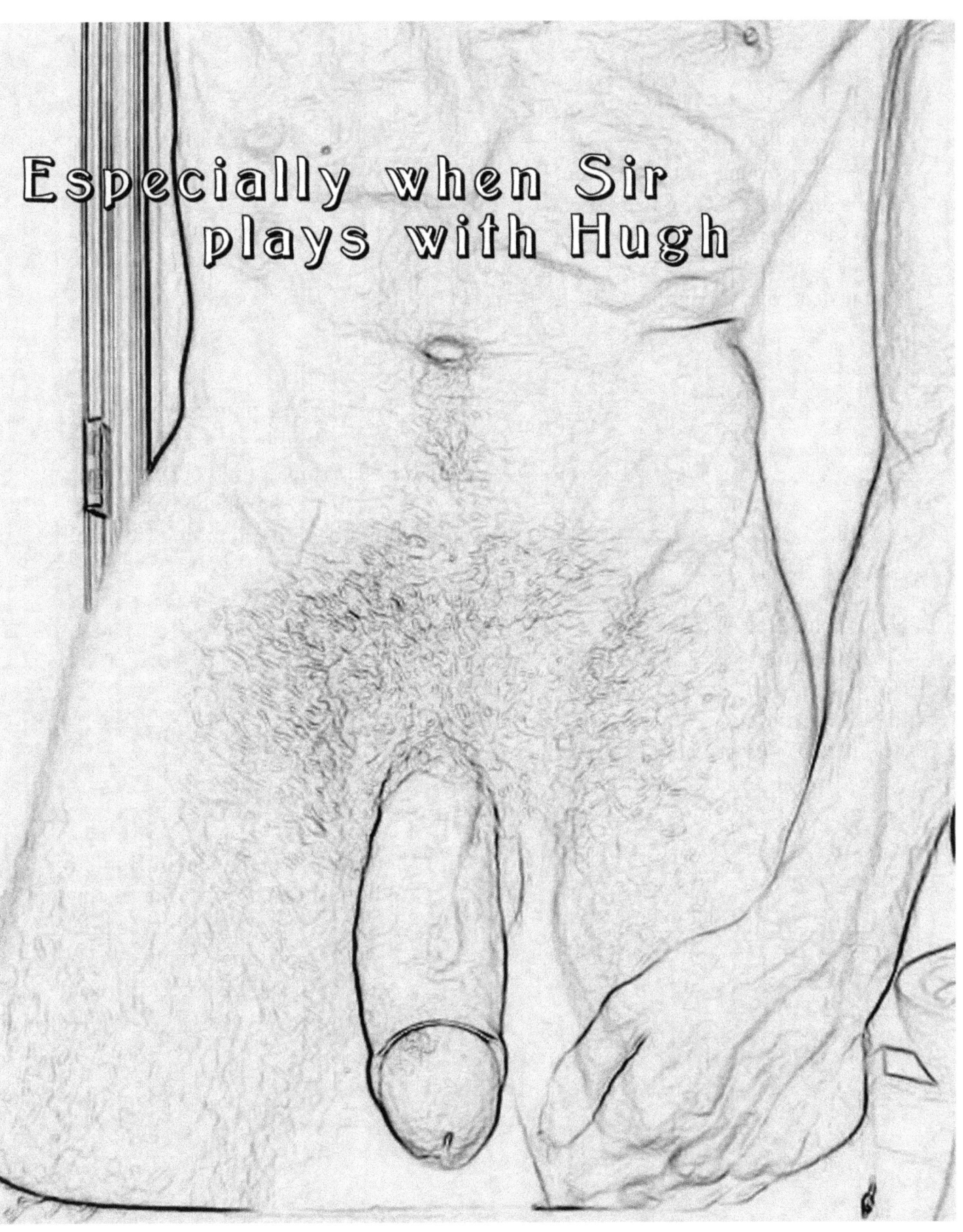

NAUGHTY LIMERICKS ROUND 1

There was a young man from Kent,
Who's dick was so long that it bent.
So to save himself trouble,
He put it in double,
And instead of coming, he went.

There once a plumber named lee,
Who was plumbing a man by the sea.
He said, "stop your plumbing,
There's somebody coming".
Said the plumber still plumbing "it's me!"

Nyphomaniacal Alice
Used a dynamite stick for a phallus.
They found her vagina
In North Carolina,
And her asshole in Buckingham Palace.

There was a young man of Bombay
Who fashioned a cunt out of clay,
But the heat of his prick
Turned it into a brick,
And chafed all his foreskin away.

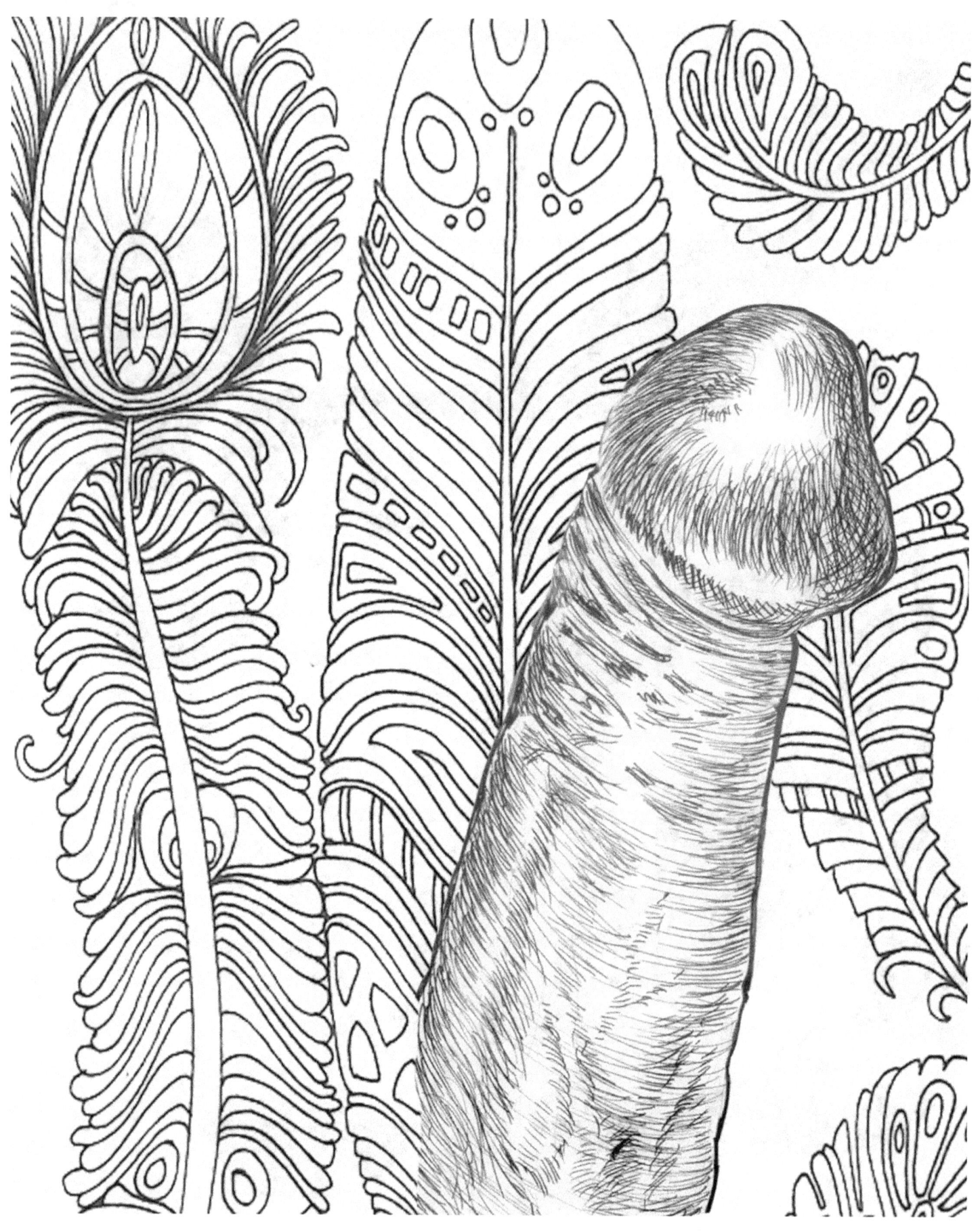

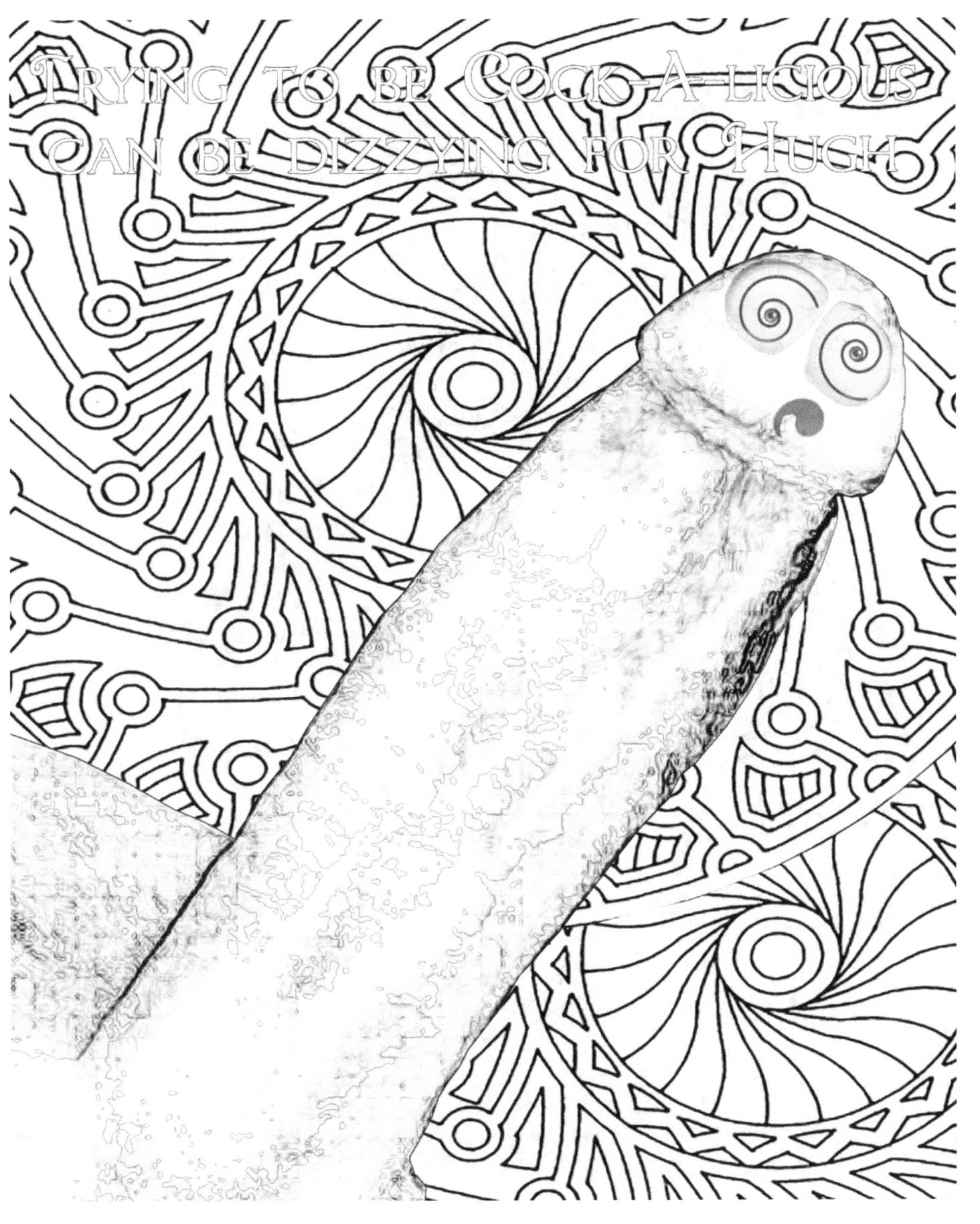

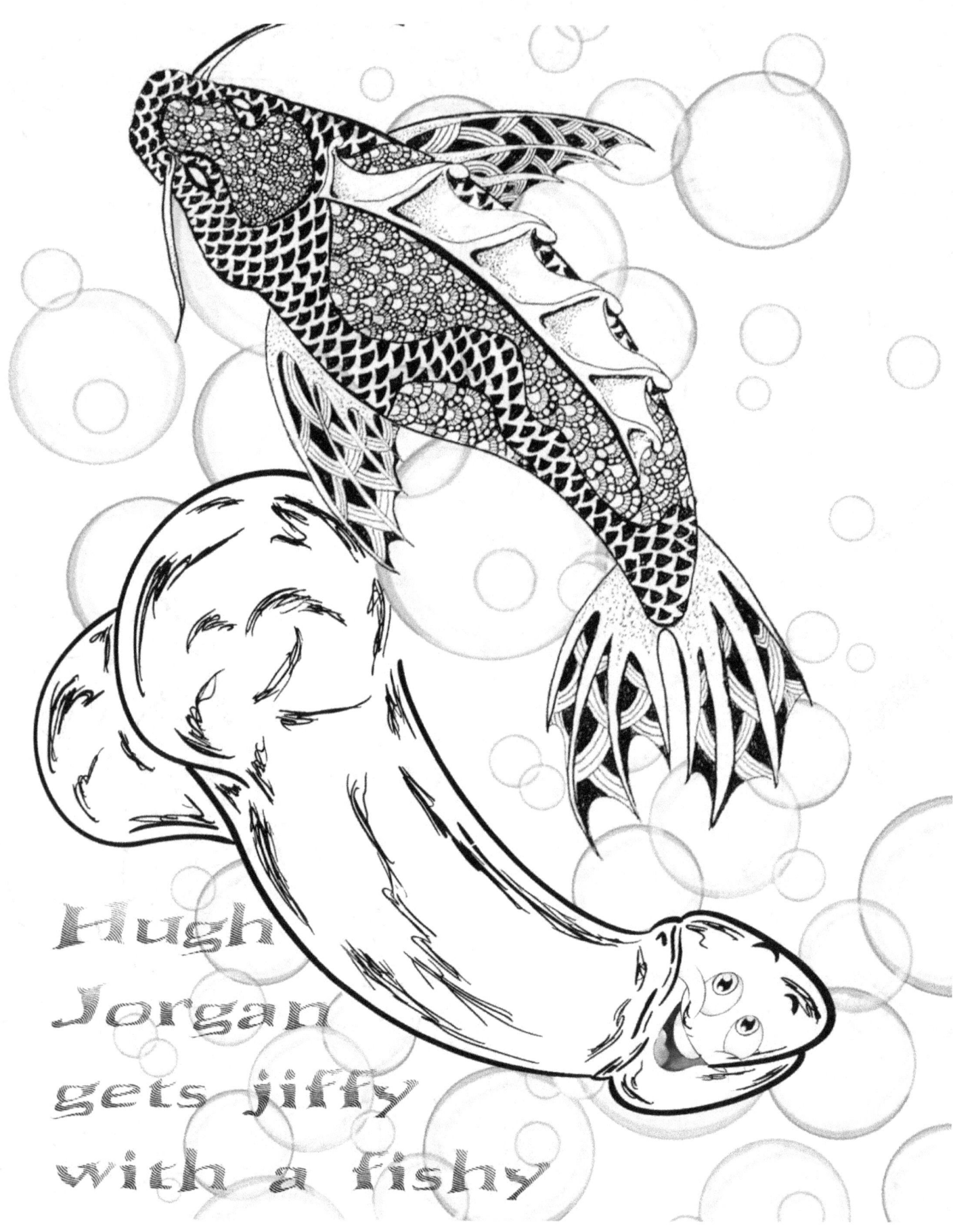

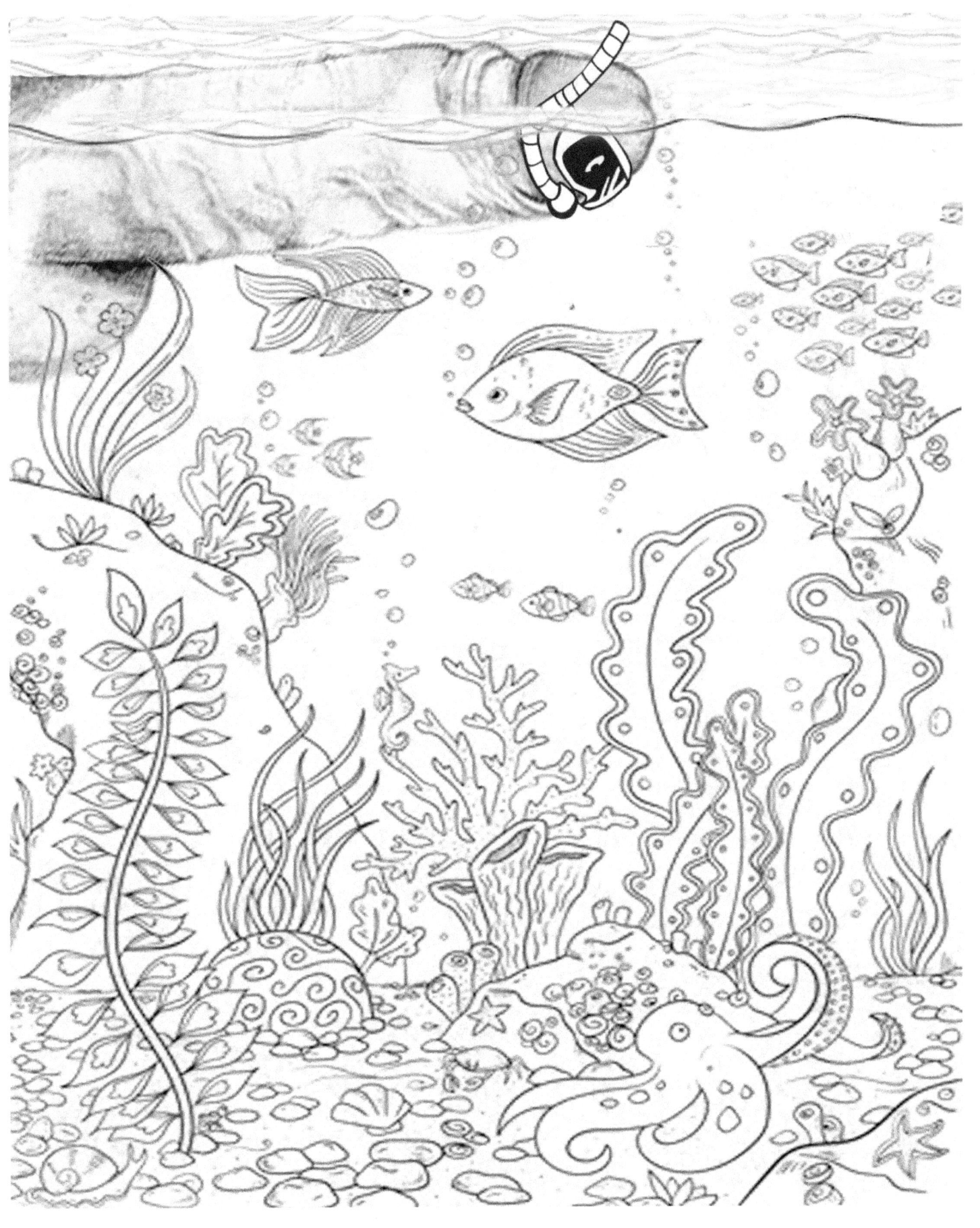

THE KOCK-AN

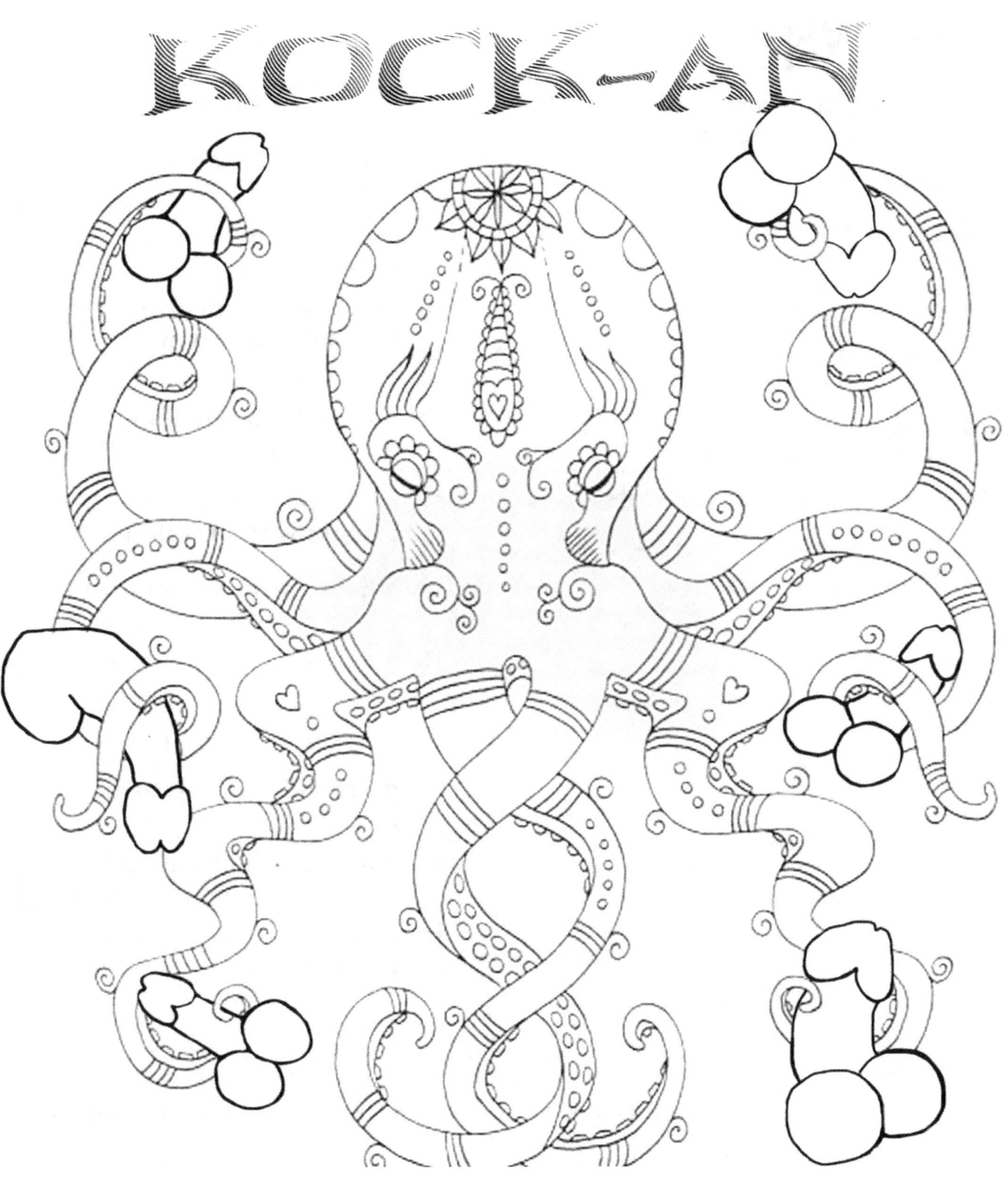

CROSSWORD PUZZLE

DOWN

1. sex position with partner on hands and knees
2. cock and _____
3. _____ your cherry
7. gay romance books are known by what initials?
8. a species of flower that resembles a nake man
10. when you're not getting and its all your fault
14. another word for testicals
15. famous statue of naked male

ACROSS

4. favorite food as an aphrodisiac
5. the more the merrier makes an _____
6. bravo in the theatre, bad mojo on the willy
9. cut
11. the best kind of friends come with _____
12. prescription medicine to help with erection
13. MF Romance are known for _____ relationships
15. a skilled oralist knows to _____ throat
16. rap it before you tap it
17. go in through the back door
18. you dont want this little fishy swimming around you
19. best spirits before and during sex

if you suck as these like I do, answers in back

When first my brave Johnnie lad
 Came to this town,
He had a blue bonnet
 That wanted the crown;
But now he has gotten
 A hat and a feather,--
Hey, brave Johnnie lad,
 Cock up your beaver!

Cock up your beaver,
 and cock it fu' sprush,
We'll over the border;
 and gie them a brush;
There's somebody there
 We'll teach better behavior--
Hey, brave Johnnie lad,
 Cock up your beaver!

~ Robert Burns c1791

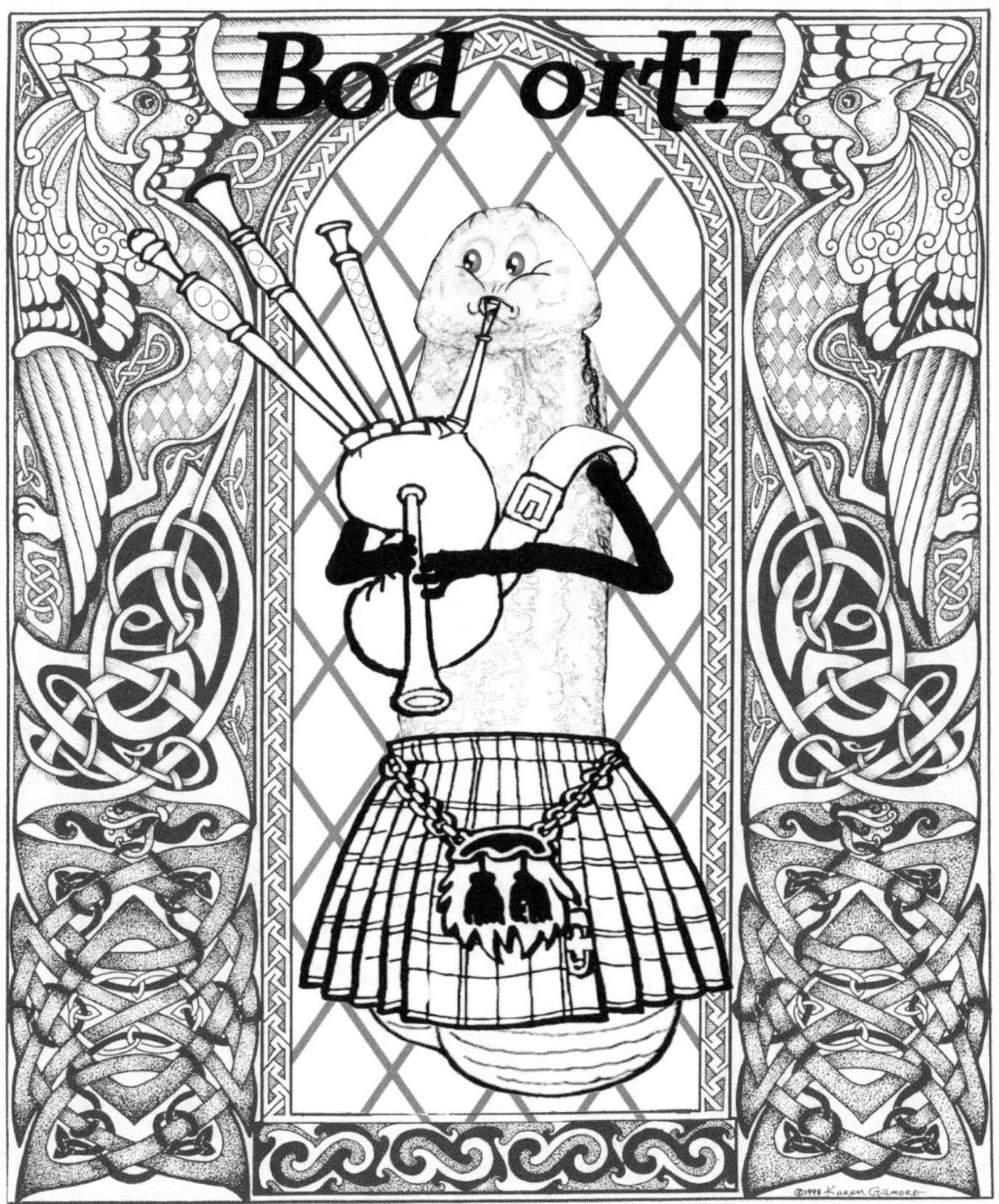

("A penis for you!")

HUGH JORGAN TRIES

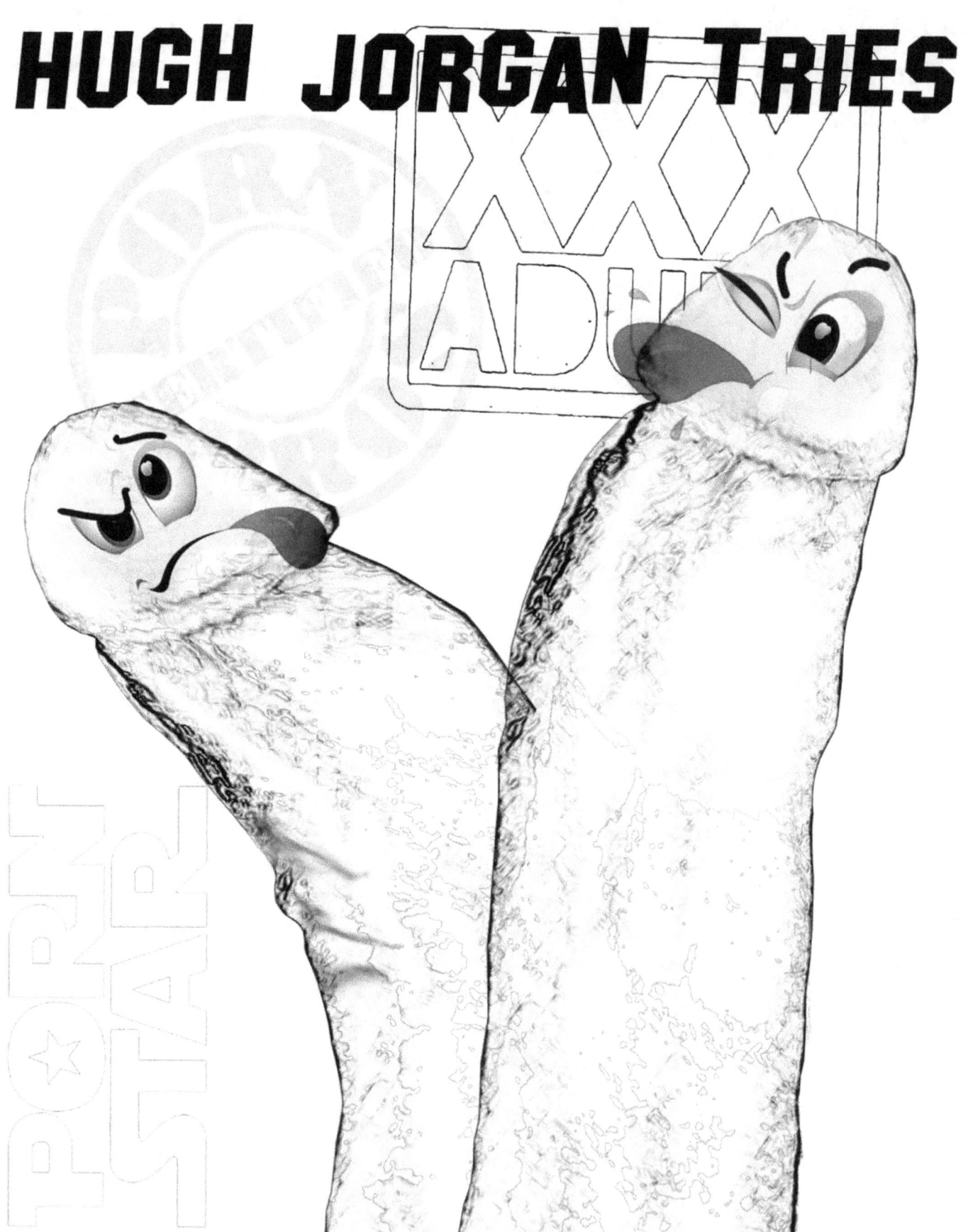

HIS OWN PORN MOVE

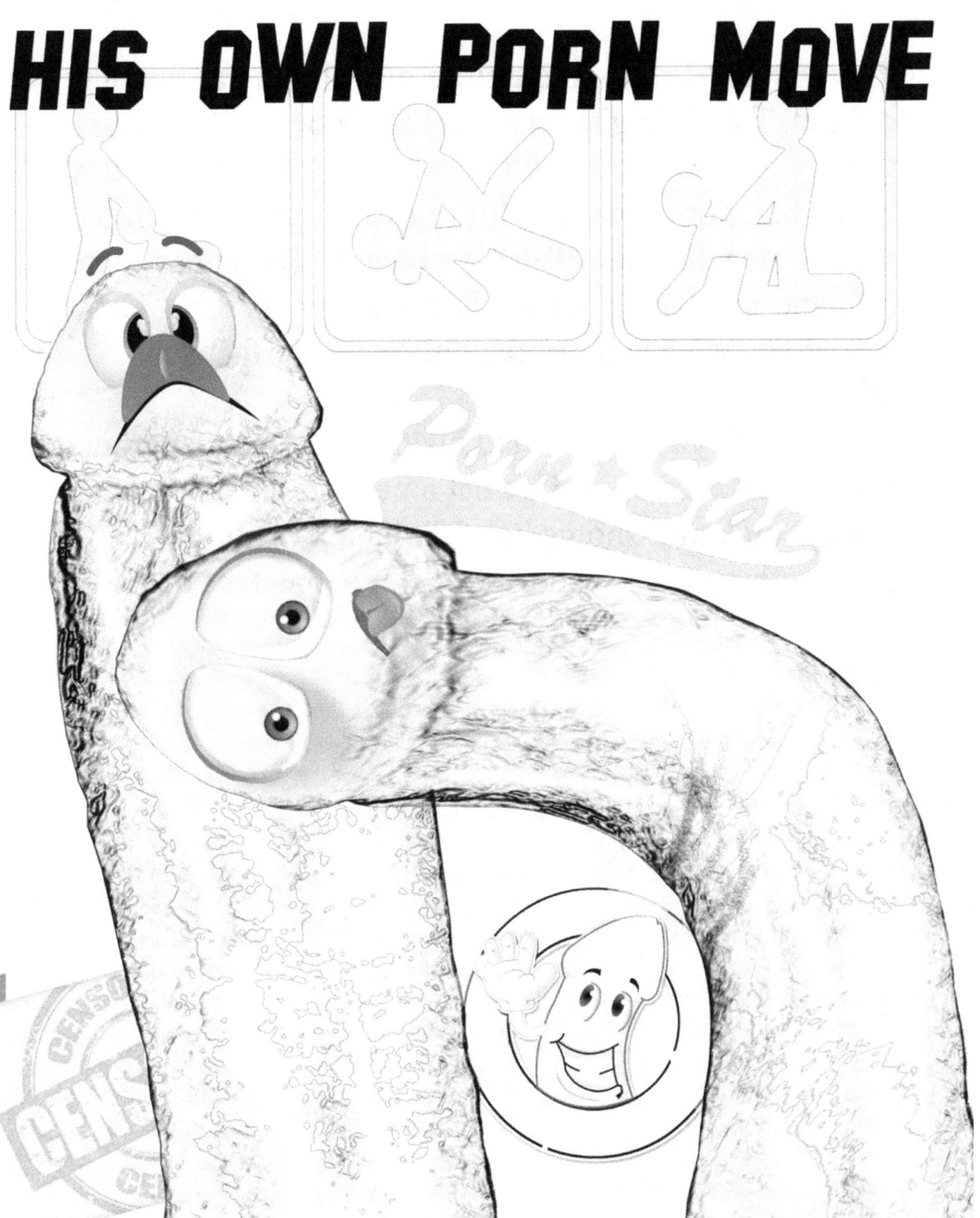

There is a little boy and a little girl playing at the playground. The little girl asks, "What's a penis?" To which the boy answered, "I don't know." Shortly after the boy heard his mother calling him in for supper. When he sees his dad, he asks, "What's a penis?" The father opens his pants and whips out his dick to show his son, "This is a penis. As a matter of fact this is the perfect penis."

"The next day the boy found his friend at the playground and she asked him again what a penis is. The boy whips out his dick and shows her, "This is a penis. In fact, if it were three inches shorter, it'd be a perfect penis."

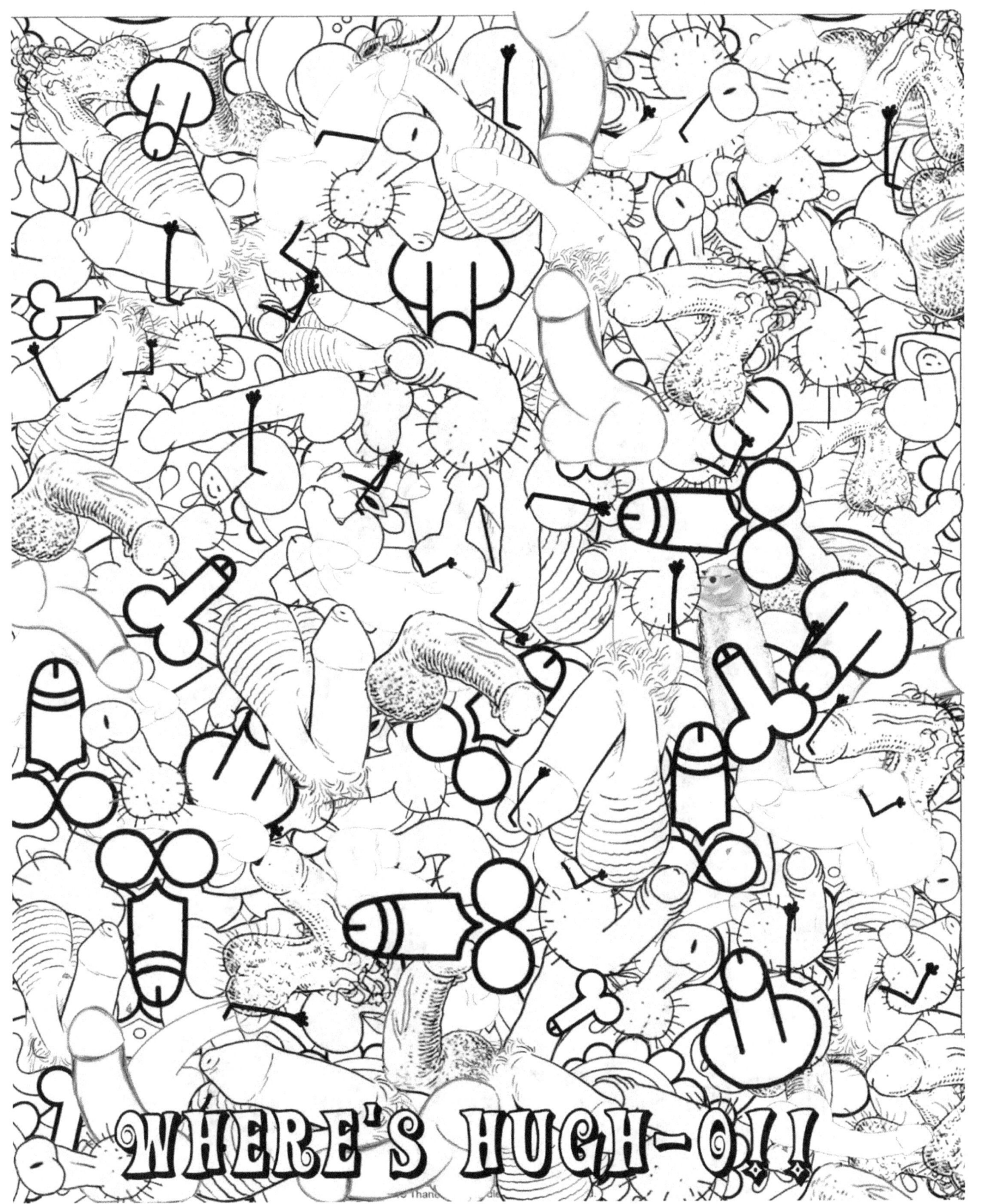

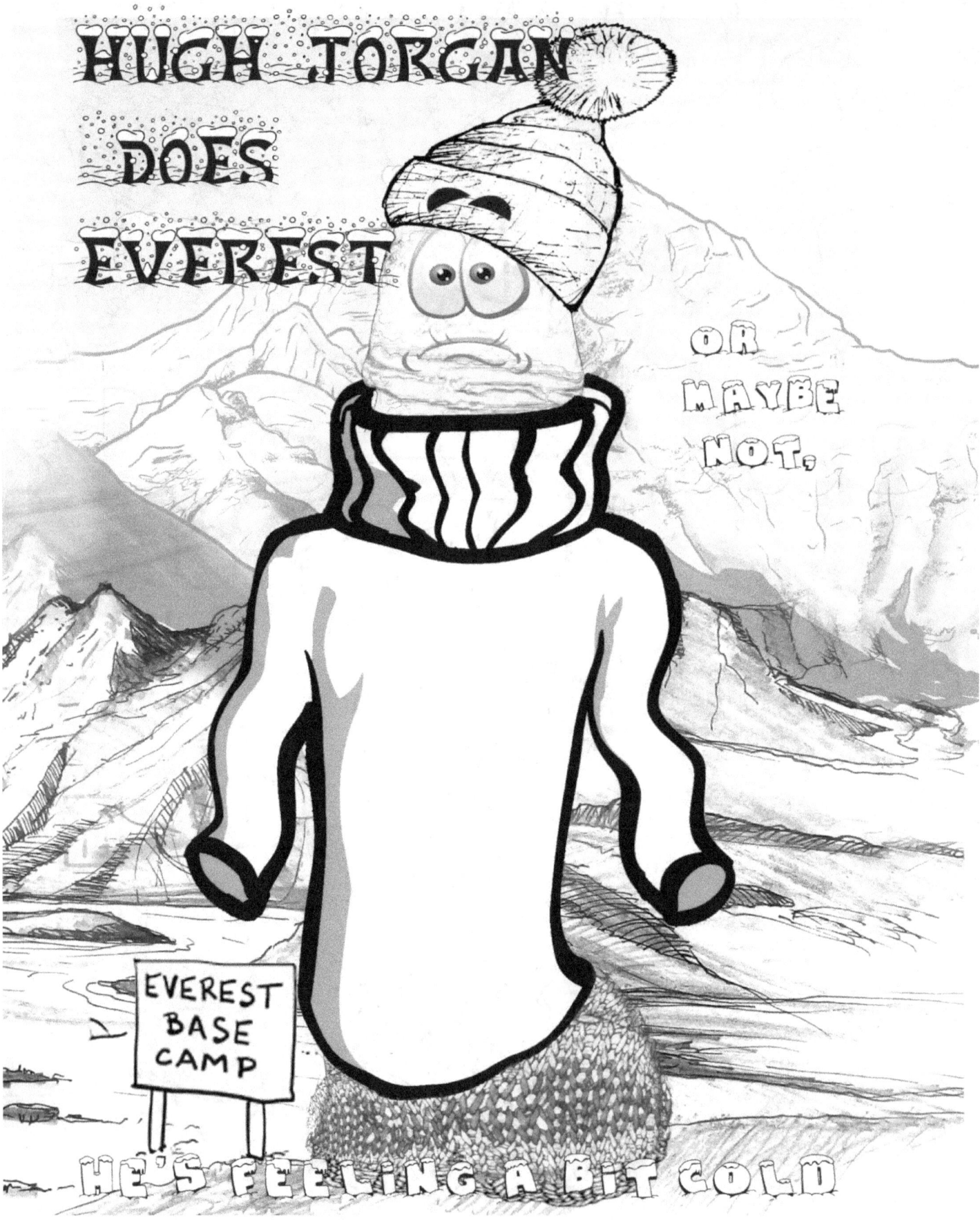

What Does a Cock and a Rubix Cube Have in Common?

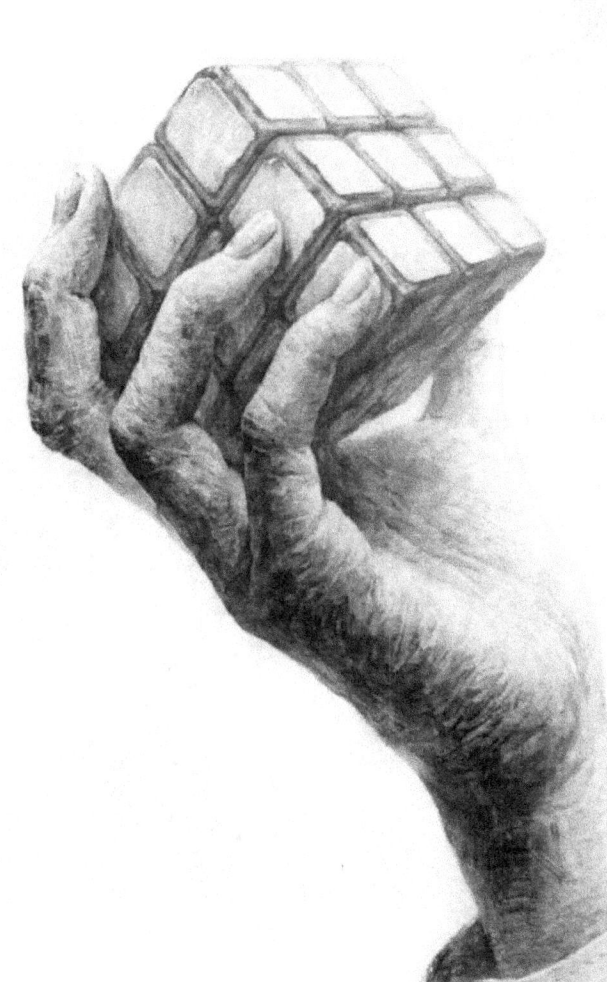

The More You Play With Them The Harder They Get

HUGH JORGAN HAS A NIGHTMARE

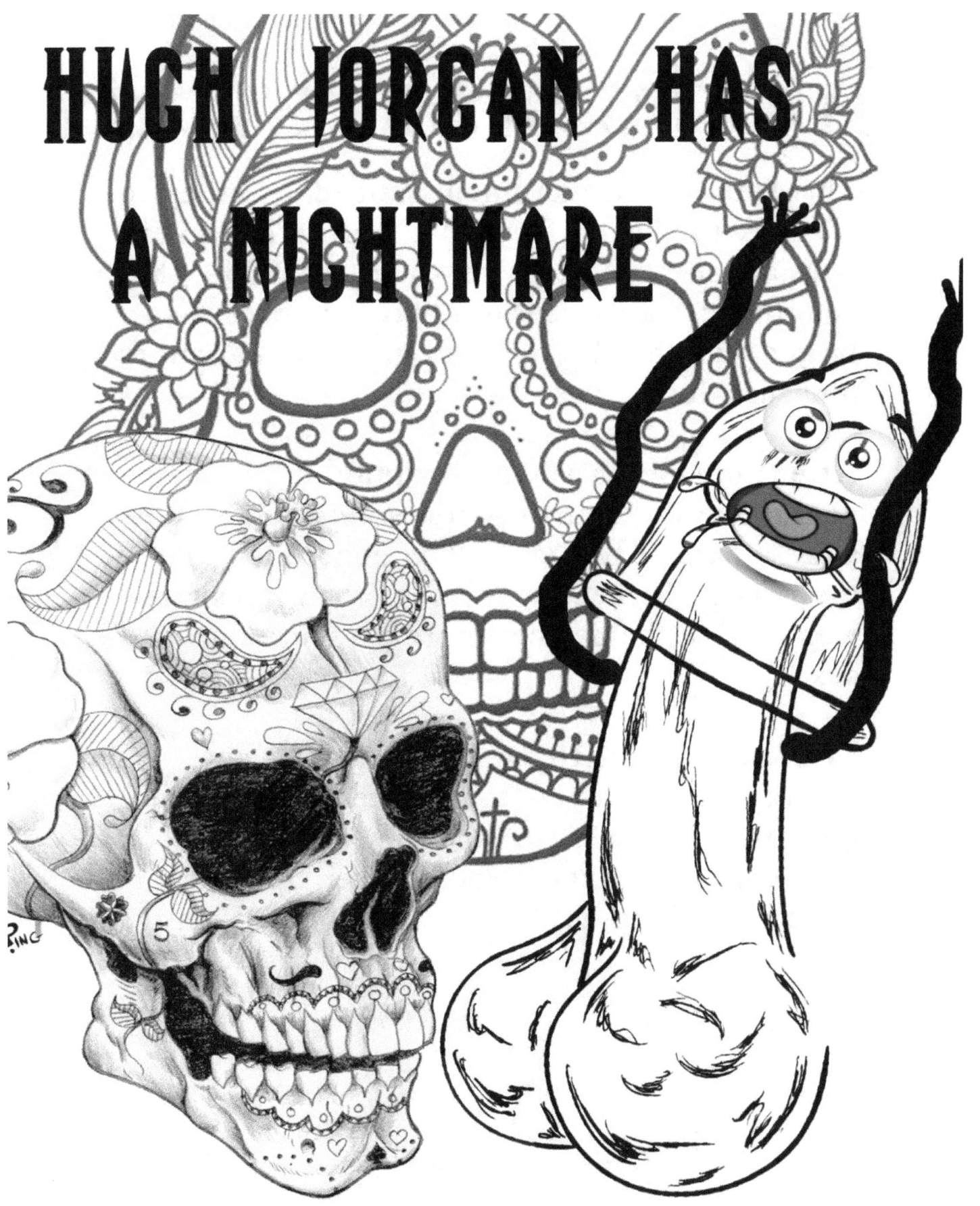

THE PECKER STUDY

The American Government funded a s study to see why the head of a man's Penis was larger than the shaft. After 1 year and $180,000, they concluded that the reason that the head was larger than the shaft was to give the man more pleasure during sex.

After the US published the study, the French decided to do their own study. After $250,000 and 3 years of reserach, they concluded that the reason the head was larger than the shaft was to give the partner more pleasure during sex.

The Irish, unsatisfied with those findings, conducted their own study. After 2 weeks, a cost of around $75.46, and many pints of beer, they concluded that it was to keep a man's hand from flying off and hitting himself in the forehead.

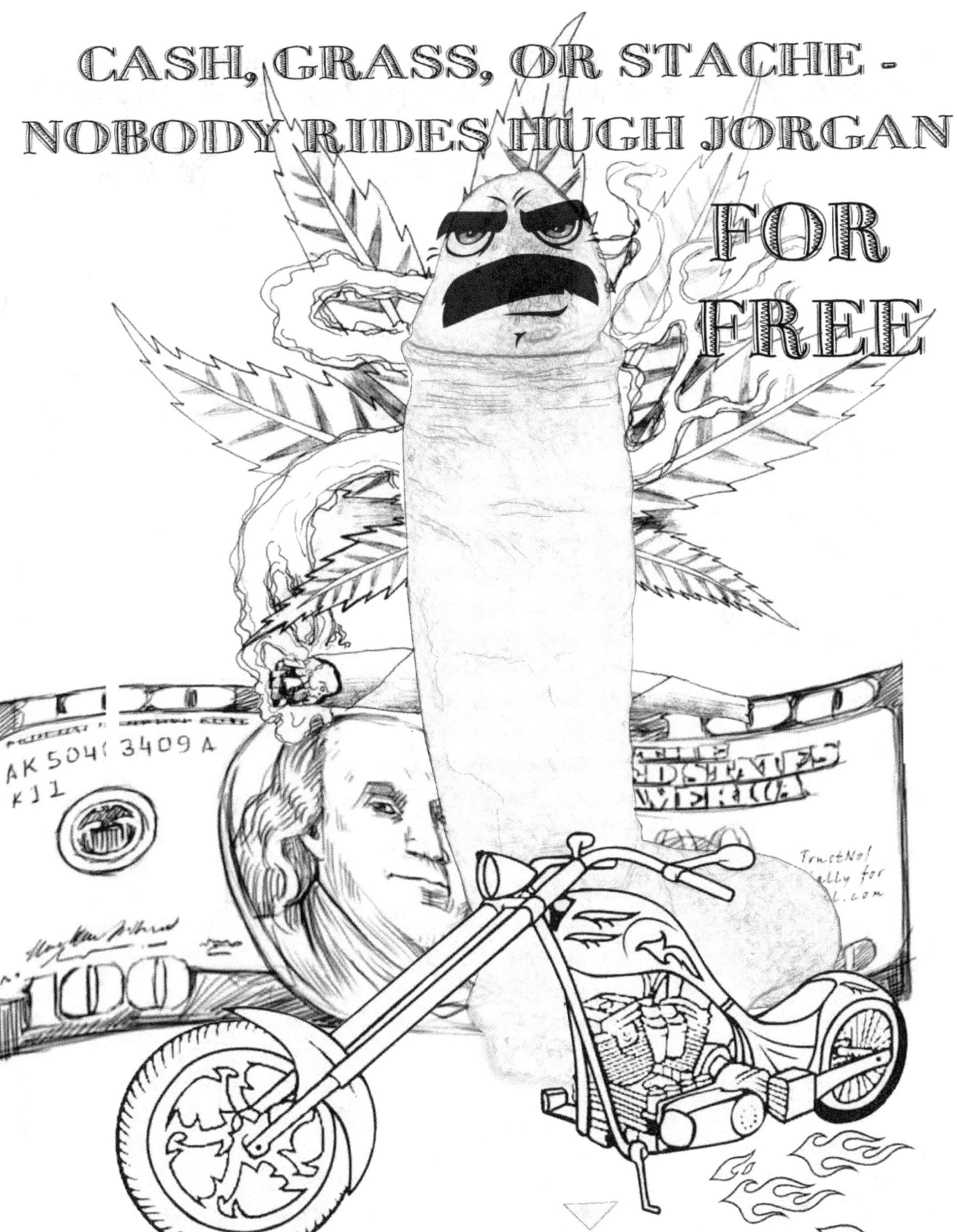

MAY THE ERECTION BE WITH YOU

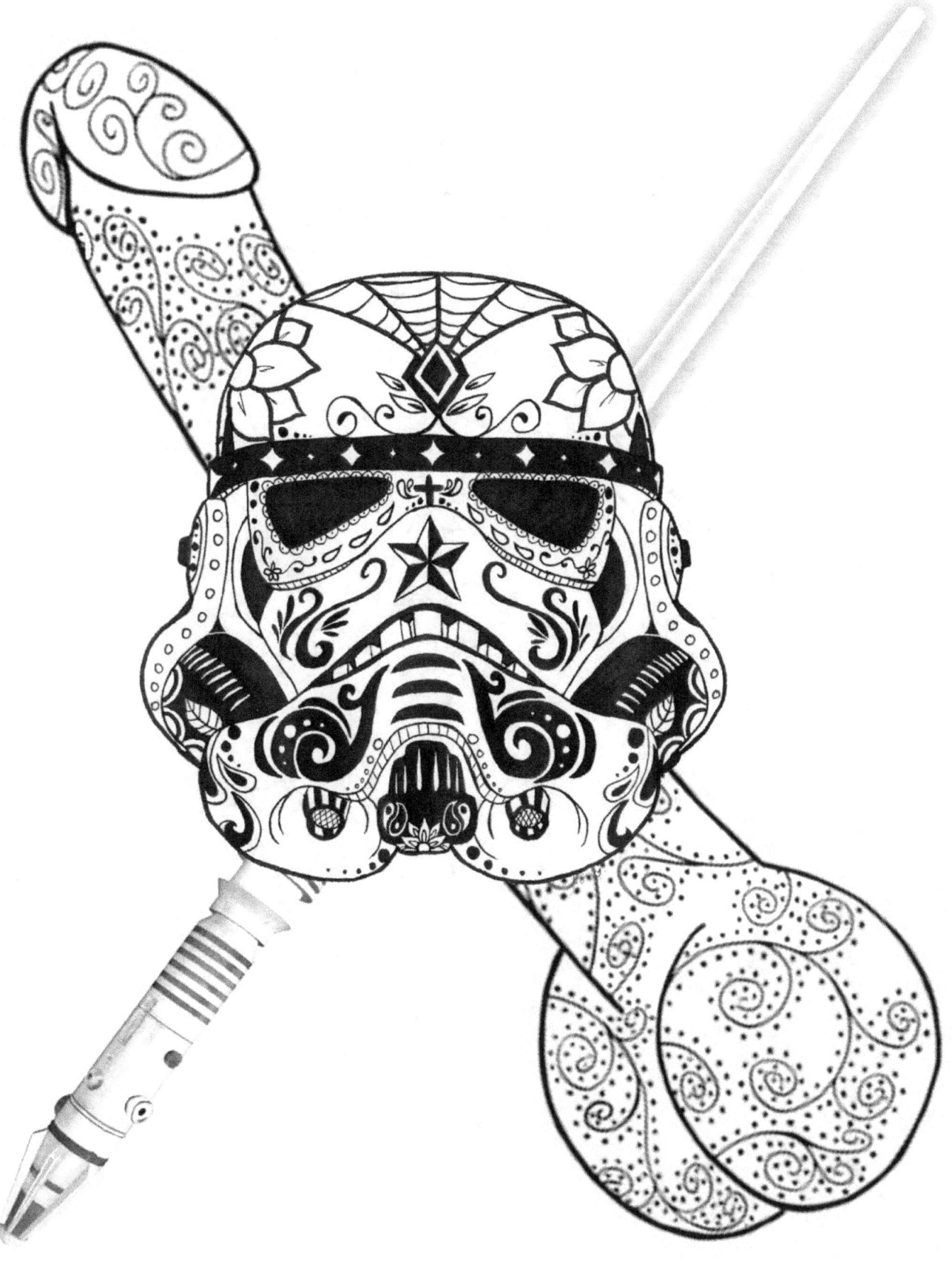

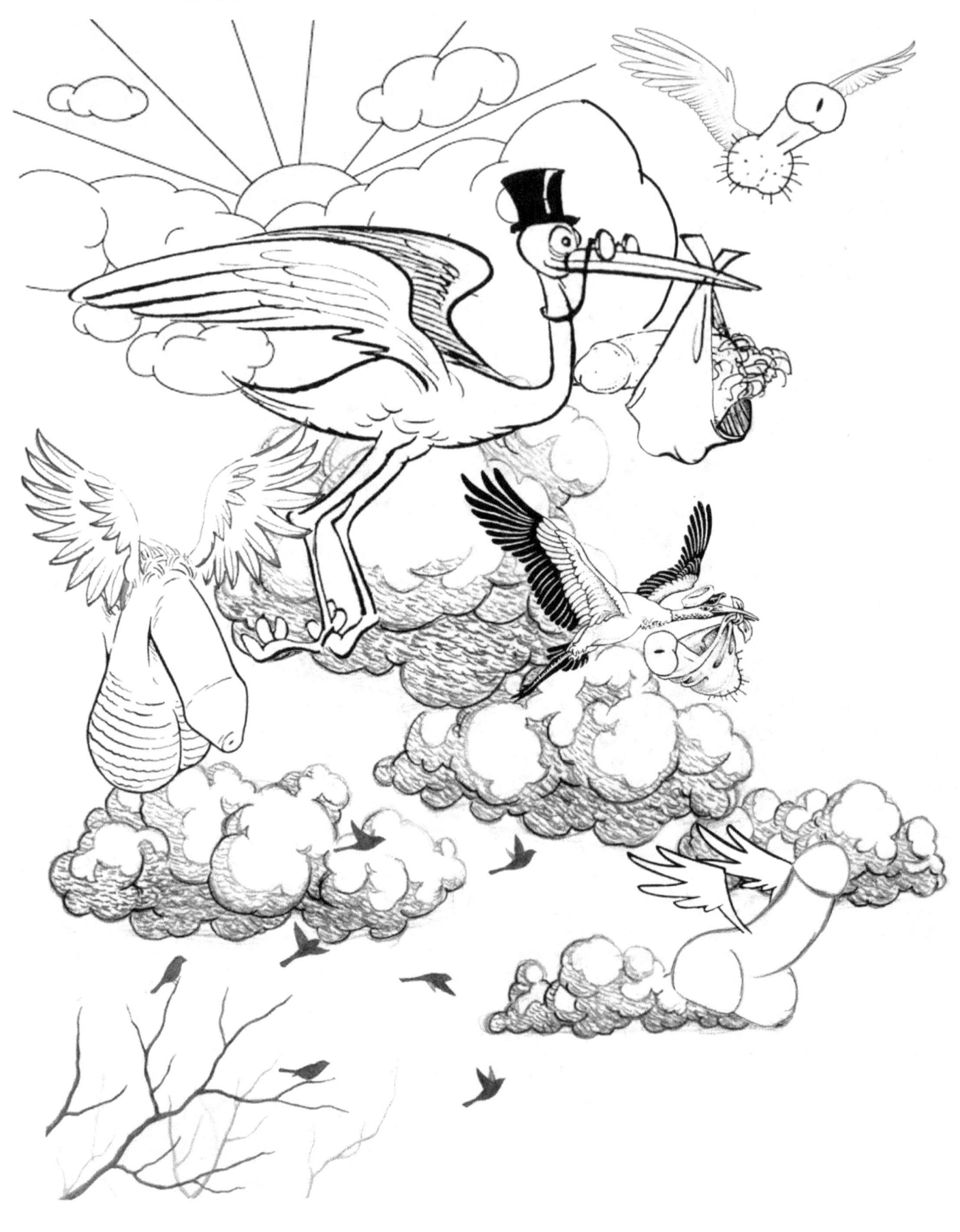

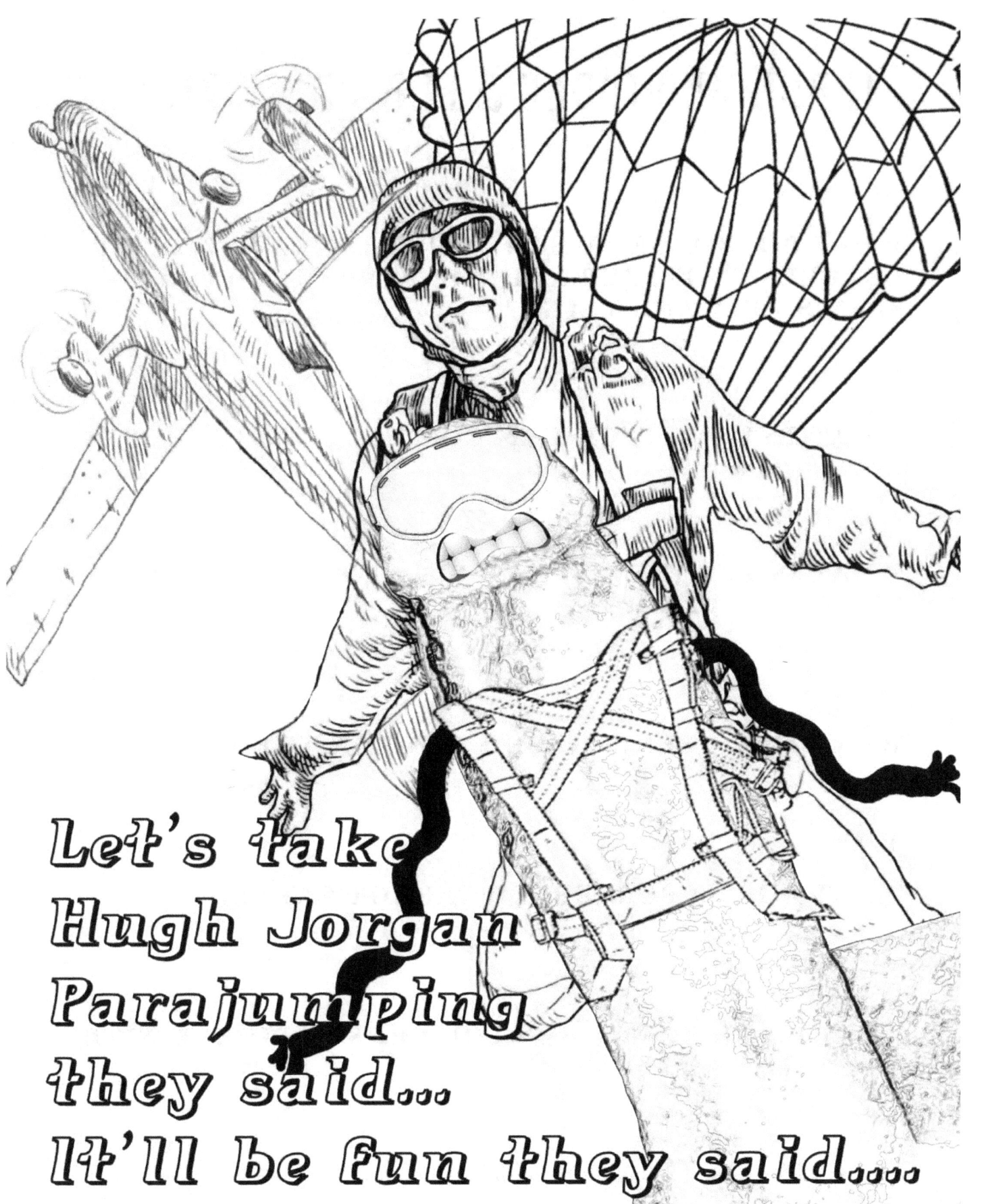

RIDDLE ME DIDDLE & FINGER ME PICKLE

WHAT DO YOU GET WHEN YOU BRING FIVE COUNTRY LEADERS TOGETHER AND THE PARTY FAVORS ARE SPANISH FLY AND VIAGRA?

WHAT TYPE OF DICK CAN COMMUTE WITH GHOSTS?

WHAT IS THE INSENSITIVE BIT AT THE BASE OF THE PECKER CALLED?

WHY DOES A PENIS HAVE A HOLE IN THE END?

WHAT DOES A PERVERTED PARROT SAY?

WHAT DO YOU GET WHEN YOU CROSS A PICKLE WITH A DEER?

At least try to answer them before you flip to the back for the answers, shesh

Answers are around back. Make yourself useful and take the trash with you.

I bet you're gonna ask, and now that you're thinking about it,
I'm bettin' you know what I'm gonna say... to the back.

Hey diddle diddle the answers are in the middle.
LOL not really, they're in back with the others.

NAUGHTY LIMERICKS ROUND 2

The modern cinematic emporium,
Is not just a simple sensorium,
But a highly effectual,
homo and heterosexual,
Mutual masturbatorium.

 An amorous sailor of Brighton
 Said to his girl, "You're a tight one!"
 She said, "upon my soul,
 You're in the wrong hole,
 And there's plenty of room in the right one!"

There once was a lass from Madras
Who had a magnificent ass.
It was not what you think,
Soft and rounded and pink,
But was gray, had long ears, and ate grass.

 There once was a man from Racine
 Who'd invented a fucking machine.
 Concave or convex,
 It fit either sex,
 But boy, was it a bitch to keep clean.

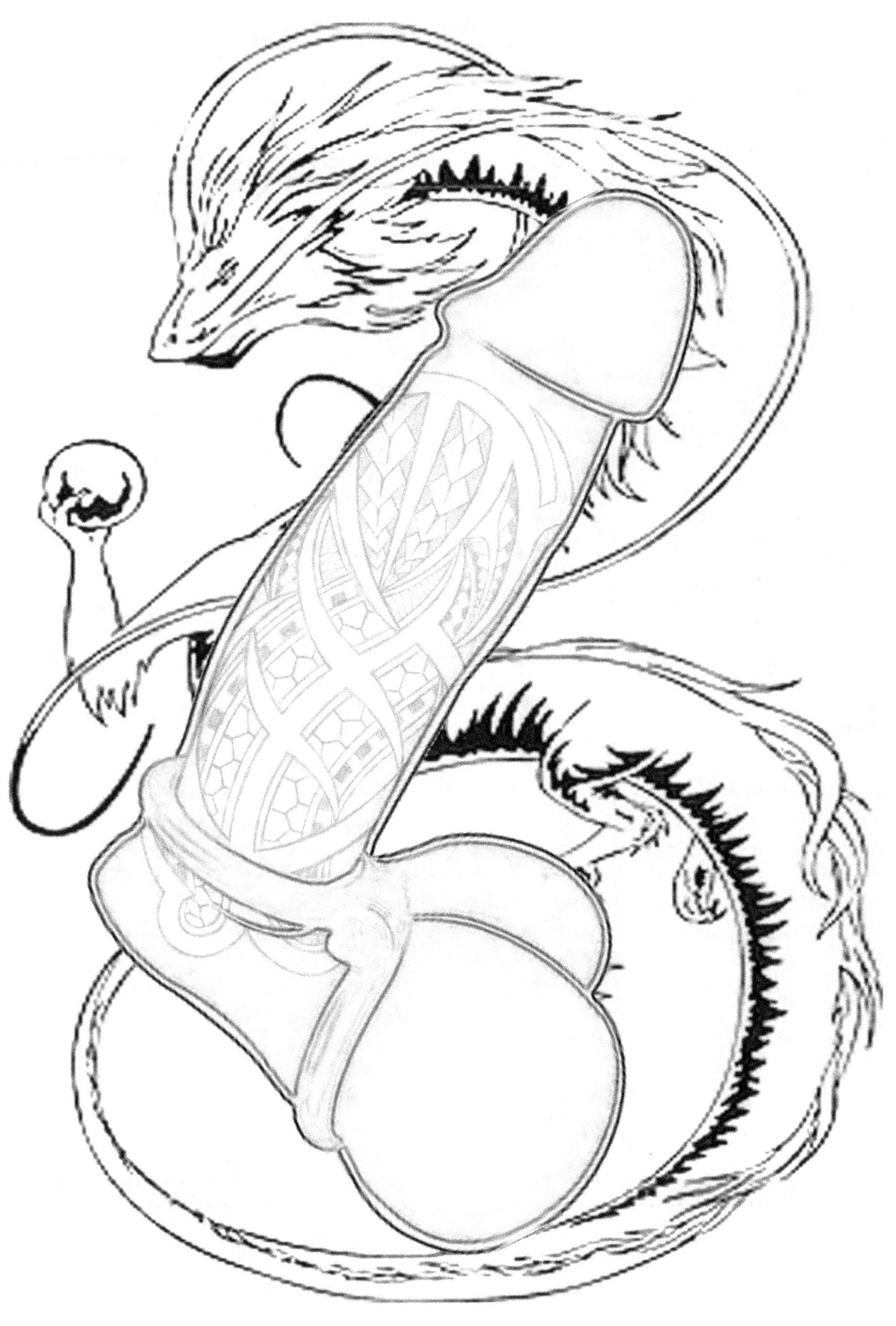

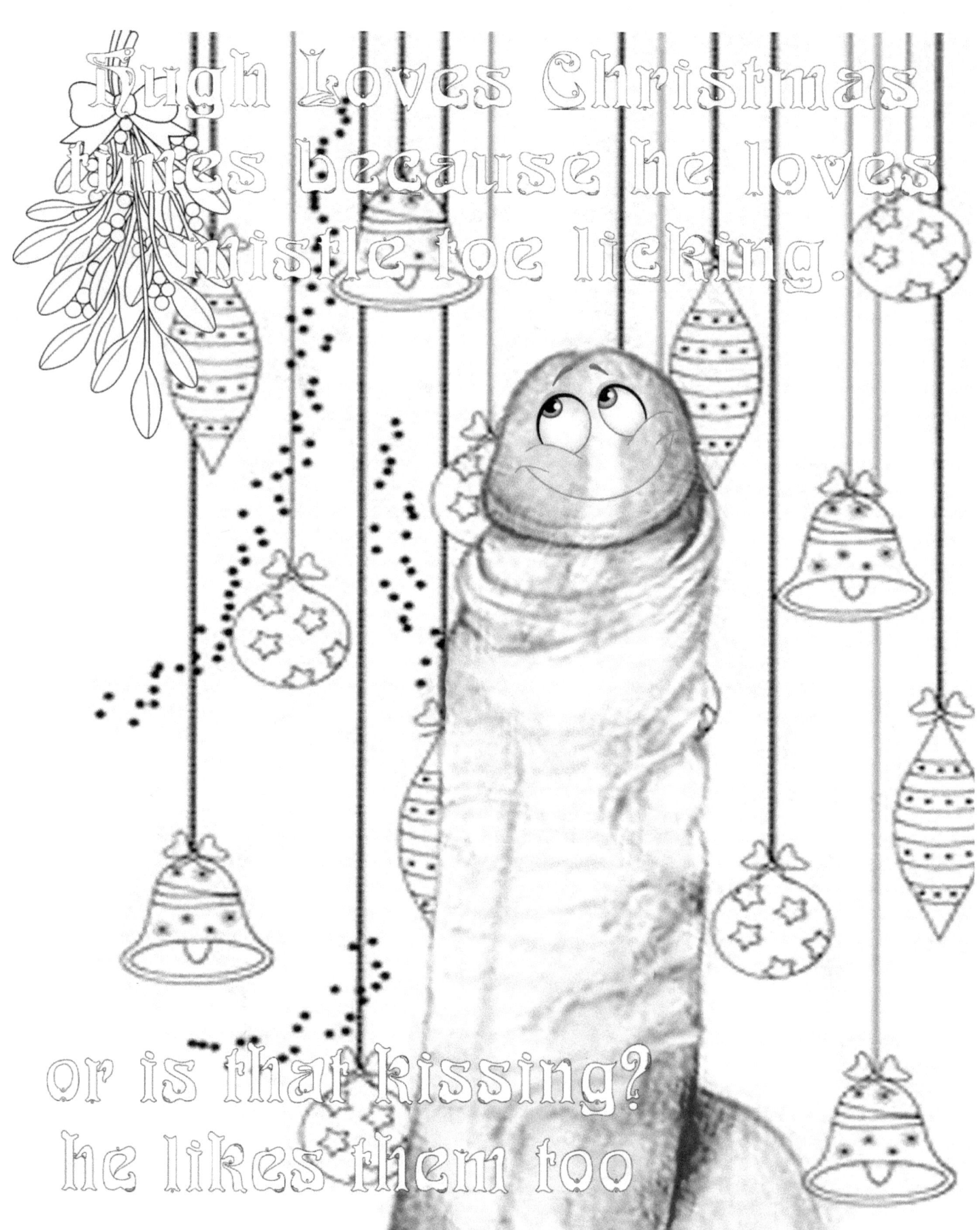

Old Hugh Jorgan had a farm—

In, out, in, out, cum.

And on his farm, he had some cocks—

In, out, in, out, cum.

With a oh, oh, here

and a mm, mm there

here a moan, there a moan,

everywhere he cums—

Old Hugh Jorgan had a farm—

In, out, in, out, cummmmmmmmmm

(thank you, thank you very much, I'm here all week)

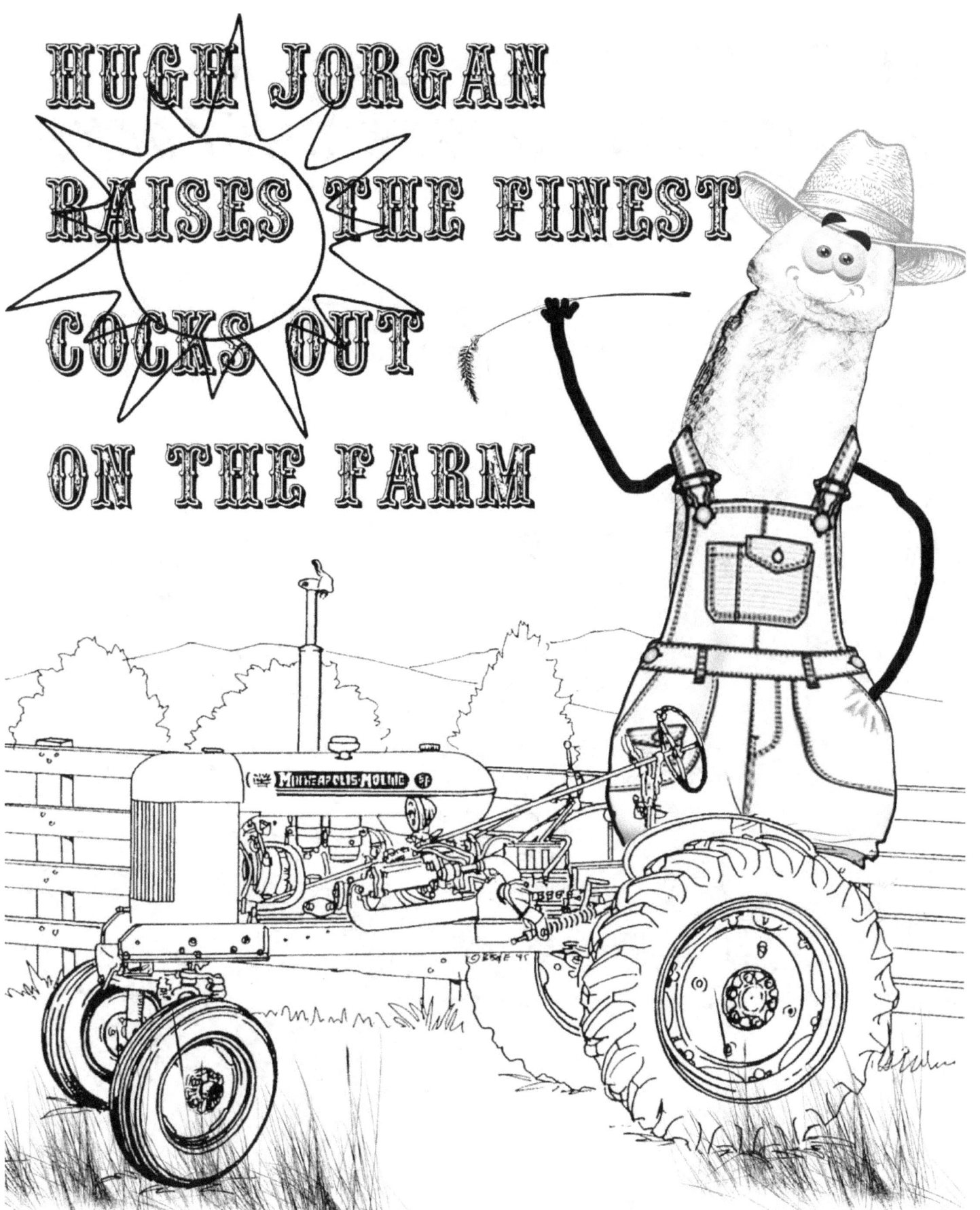

HE PROUDLY GROWS COCK ON THE COB, RAISES CHI-COCKS,

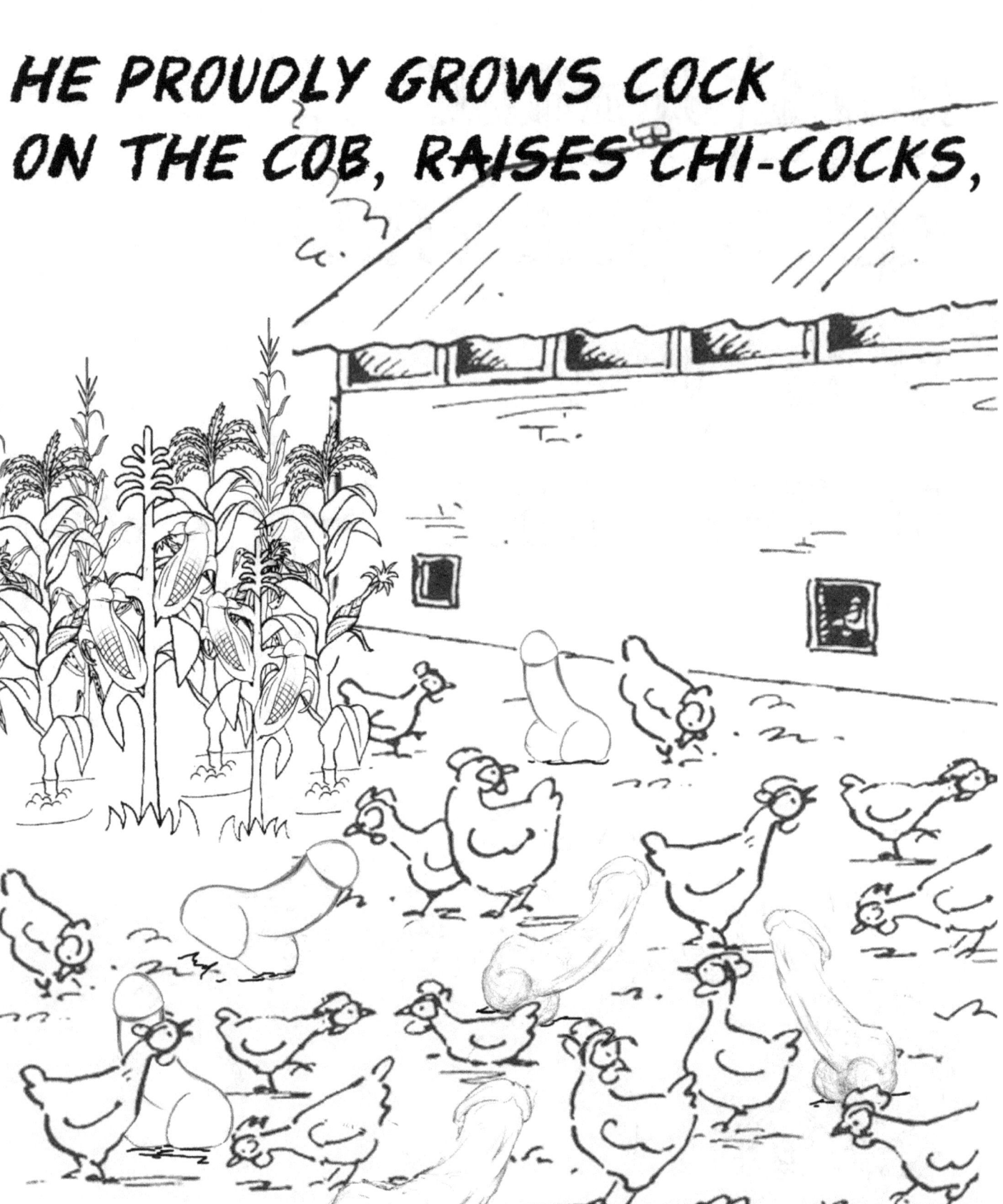

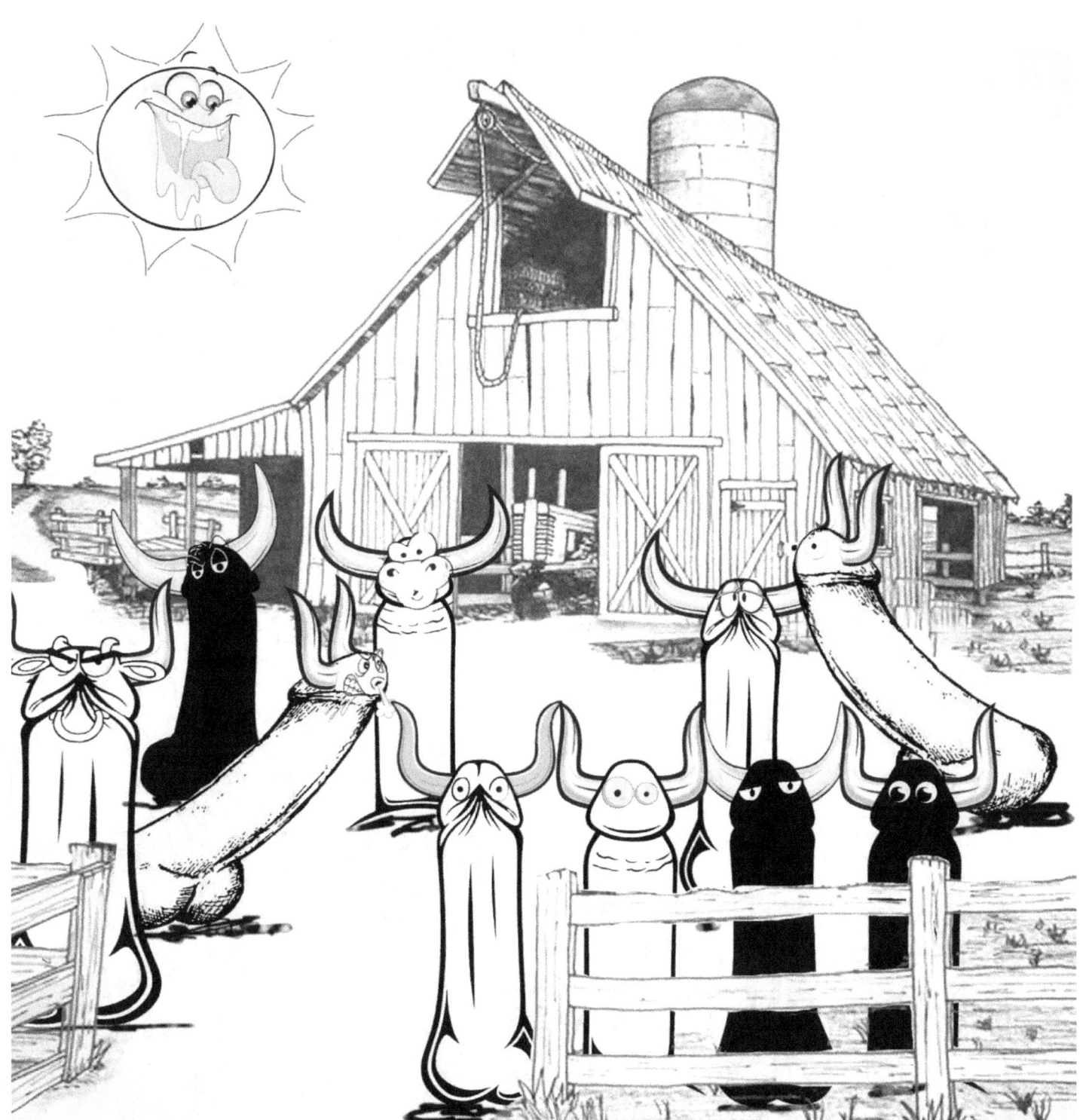

COCKY WORD SEARCH

- COCK
- BIG RED
- TALLYWHACKER
- TOOL
- HE-MAN
- DICK
- IVAN
- ROD
- MR. D
- HUNG WEI LO
- HUGH (JORGAN)
- PEETER
- BA DUNK A DONK
- ZIPPER WOOKIE
- LONG DONG SILVER
- OL' ONE EYE
- LITTLE ELVIS
- BONER
- WOOD
- POPE JOHN POLE III
- FIREHOSE
- CYCLOPS
- POCKET ROCKET
- TENTPOLE
- PECKER
- JOHNSON
- WEINER
- TONSIL TICKLER
- CHOAD
- WANKER
- SCHLONG
- SCHLITTLE

FOR CHEATERS, ANSWERS IN BACK

```
M F T O N S I L T I C K L E R X
B E K U Y S A N A R Q B H G E N
J L I T T L E E L V I S U K O O
H T M D O C Y C L O P S N R N L
U T O R M S A T W K E C G E A I
F I R E H O S E H B E I W V W O
M L O Z A S D S A E T M E L N B
Z H D Q W C P E C K E R I I O A
I C E K O H I V K F R X L S C D
P S J C F L X D E Z C D O G V U
P O K G B O N E R O J M L N H N
E L O P T N E T D M F L R O U K
R C L B V G R L N C H O A D G A
W O O D I W C A N Q E T U G H D
O K N R A G M J O H N S O N T O
O W E I N E R S K A V H D O J N
K J E Z H D X E T O X I I L L K
I X Y C F L H E D S C R F V D C W
E T E K C O R T E K C O P Q A W N
P O P E J O H N P O L E I I I N
```

HUGH JORGAN LOVES YOU, AND YOU, AND YOU TOO !!!

Is Your Penis Good-Looking?

Women view these parts as most important in an attractive penis

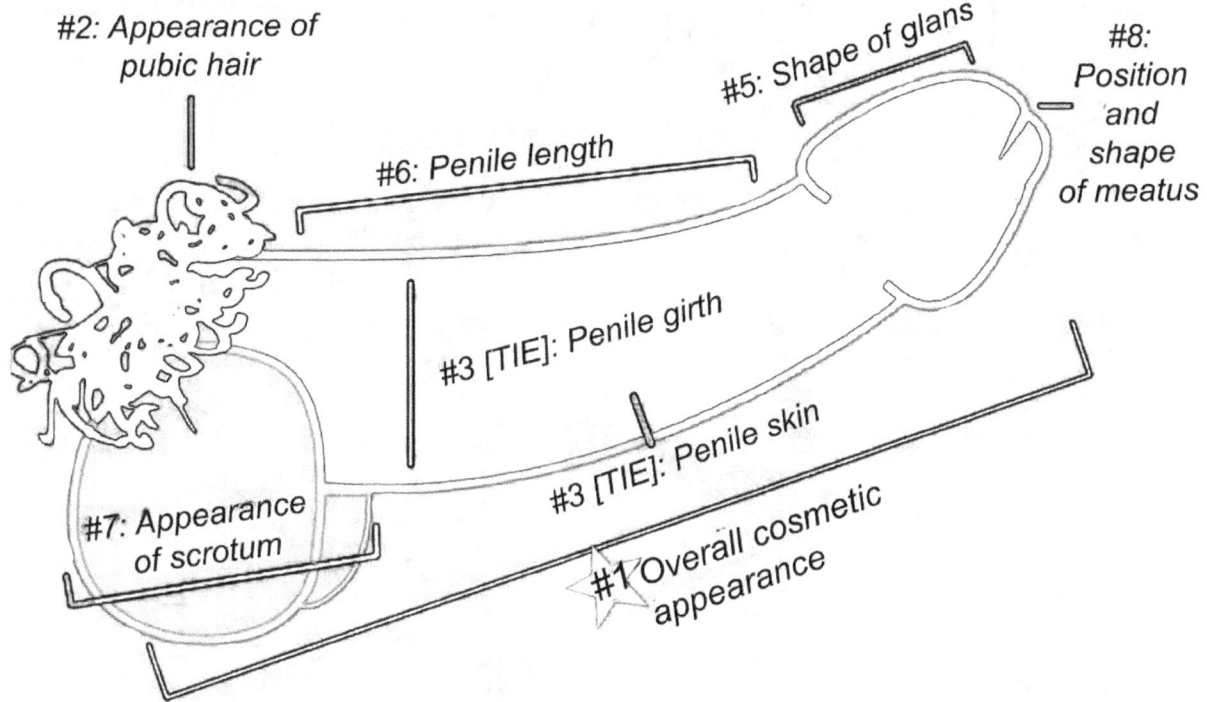

Gay men view these parts as most important in an attractive penis

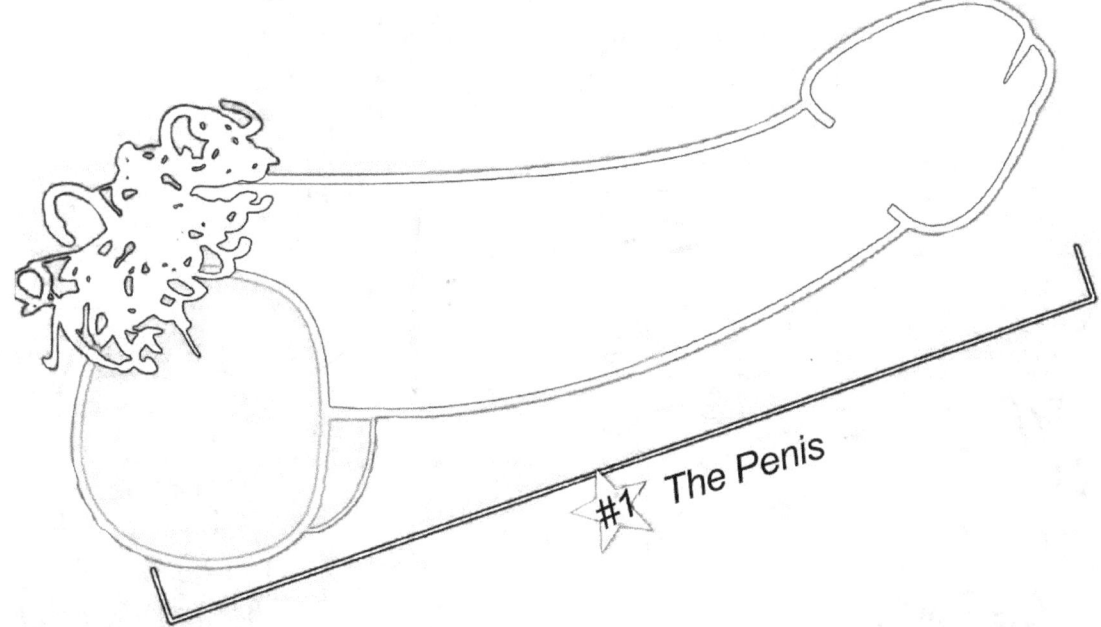

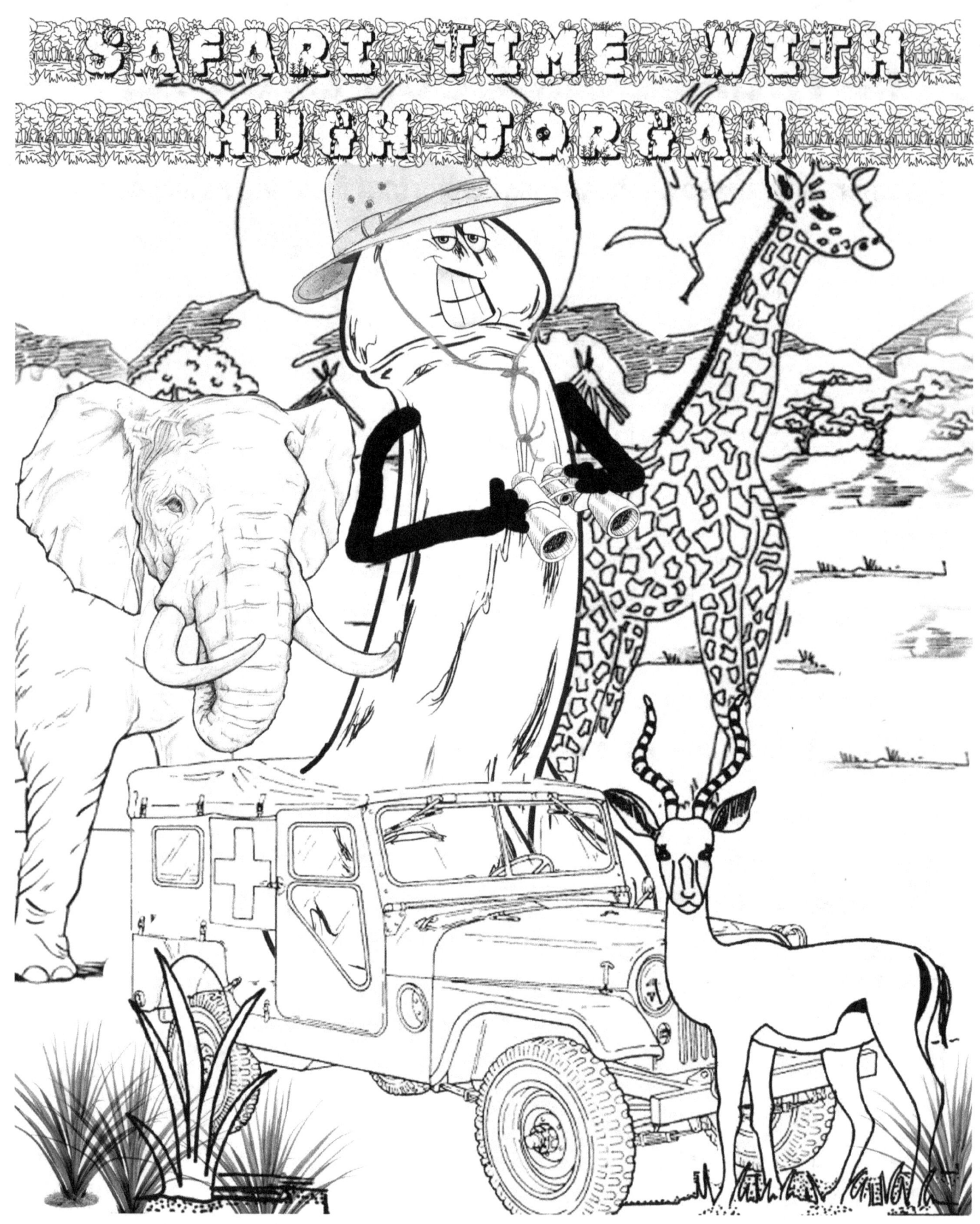

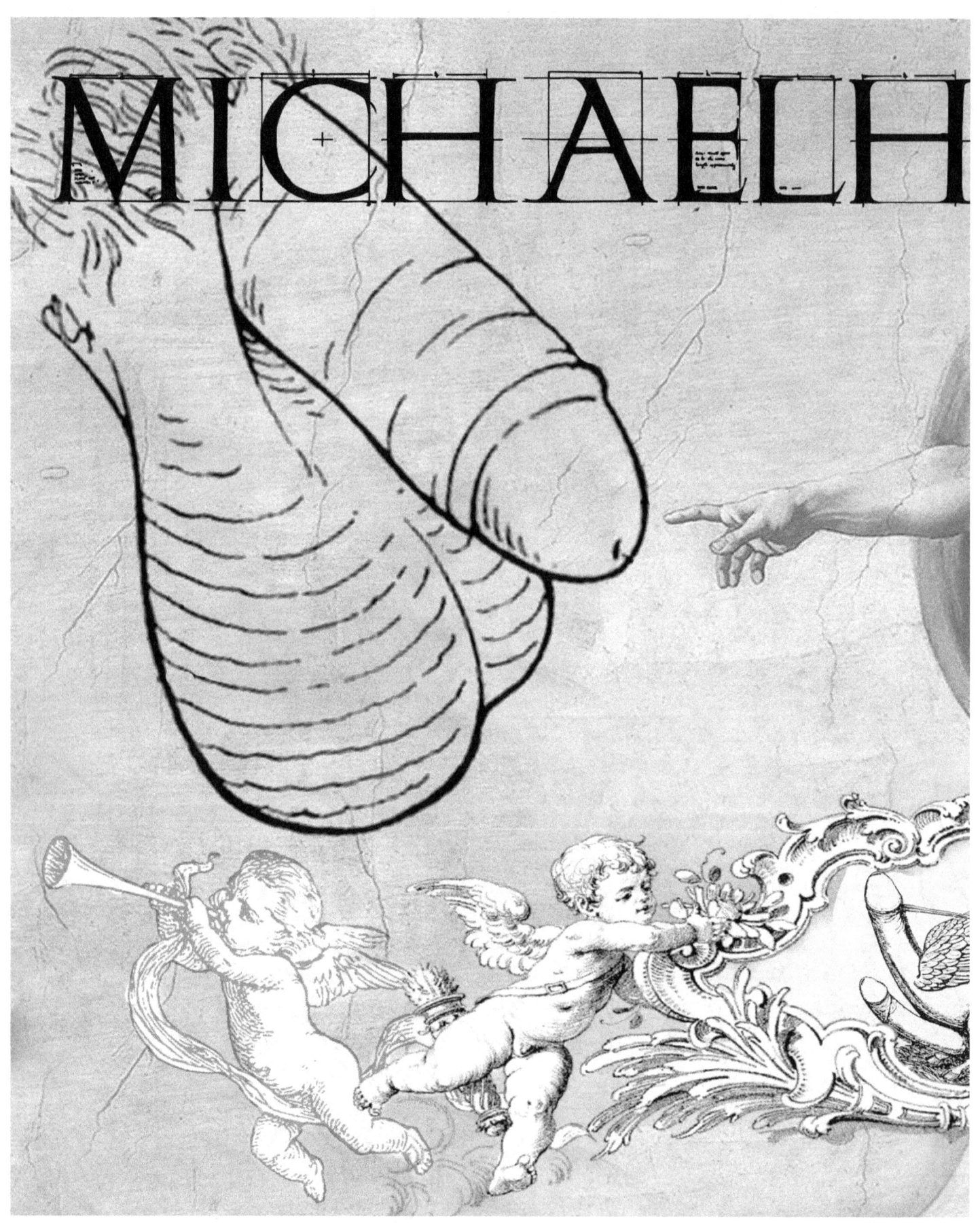

UGHGELO

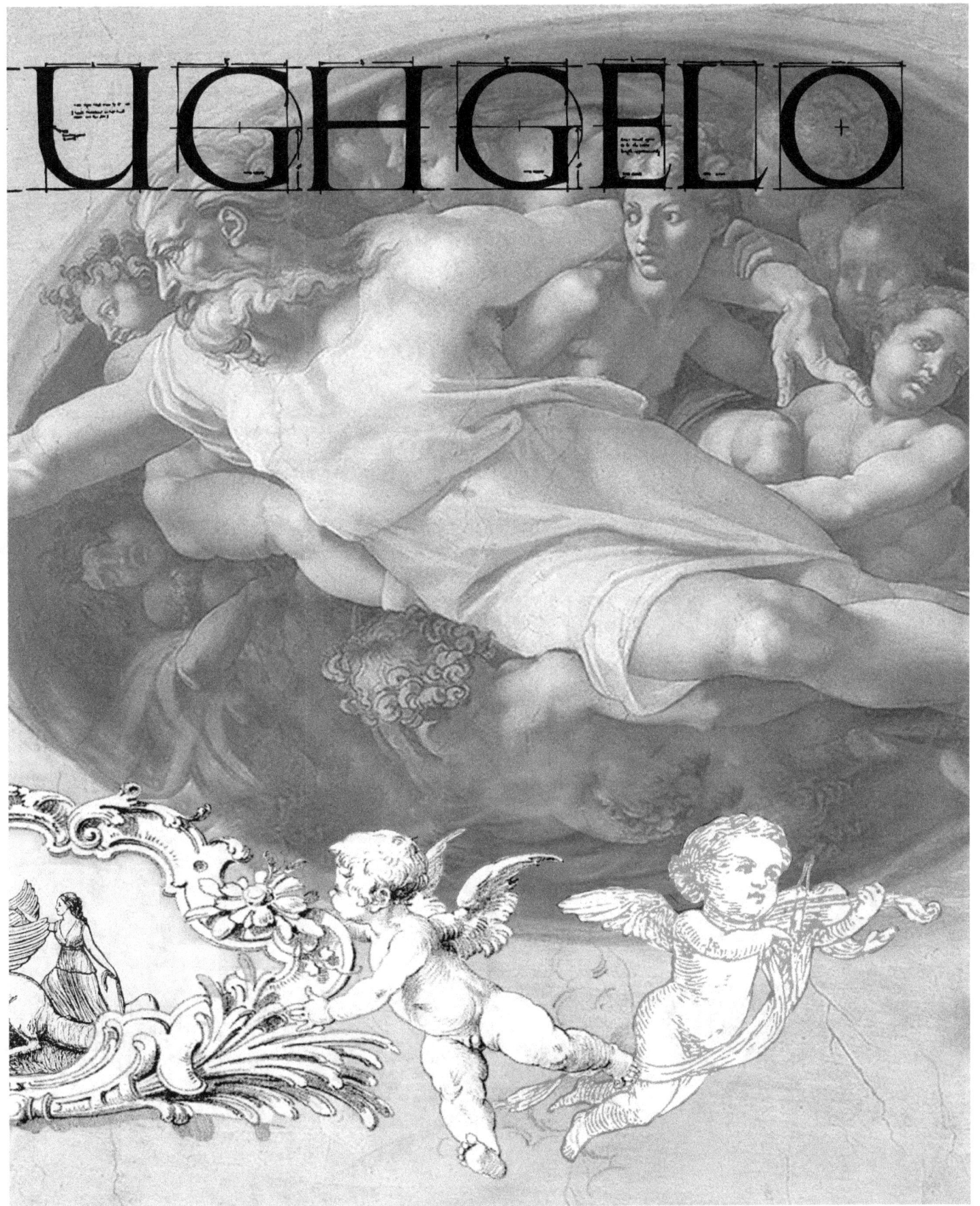

SCROTUM FEUD

How to play: Come up with as many single word answers you can think of and write them into the game box. When your done, go to the answer sheet in the back (no cheating) and find which of your answers are in our list. Write down the values for all your matched answers and total them up to see if your a big pecker winner!

AND THE QUESTION IS...

NAME A FAVORITE PLACE MEN LIKE TO PUT THEIR DA-DUNK-A-DONG IN

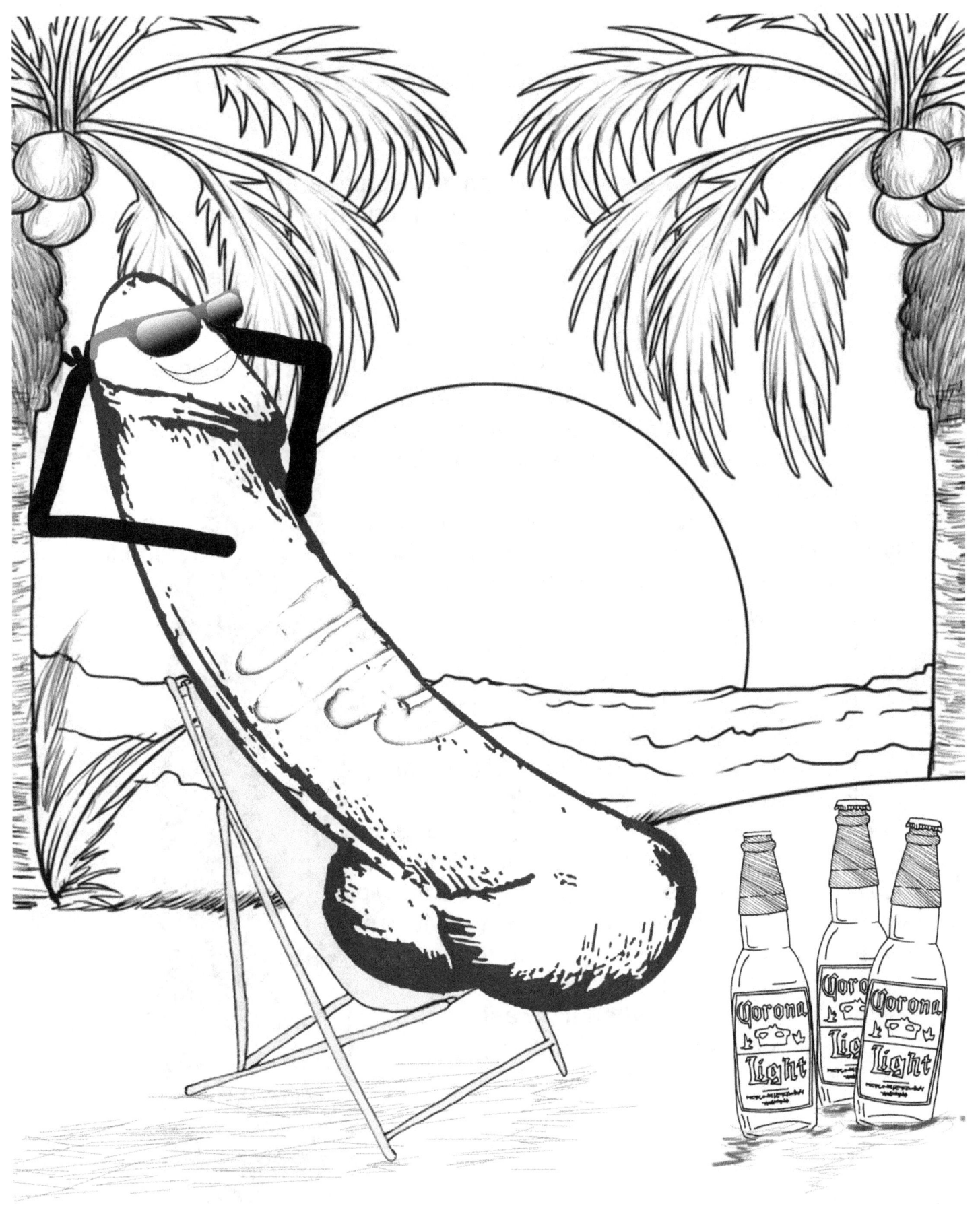

My Ankle Banger is soooo BIG!

My dick is so big, there's still snow on it in summertime
My dick is so big, I went to the Viper Room and my dick got right in. I had to stand and argue with the doorman.
My dick is so big, I have to call it Mr. Dick in front of company.
My dick is so big, it has casters.
My dick is so big, it has a three picture deal.
My dick is so big, no matter where I go, my dick gets there first.
My dick is so big, a homeless family lives underneath it.
My dick is so big, it was almost drafted by the Cleveland Browns, but Art Modell didn't want a bigger dick than himself.
My dick is so big, it seats six.
My dick is so big, everytime it gets hard it causes a solar eclipse.
My dick is so big, King King is going to crawl up it in the next remake.
My dick is so big, the city had to carve a hole in the middle of it so cars could get through.
My dick is so big, I have to use an elastic zipper.
My dick is so big, it has investors.
My dick is so big, its takes four Russian wrestling woman and a team of Clydesdales to jack me off.
My dick is so big, it requires air traffic warning lights.
My dick is so big, it has its own zip code.
My dick is so big, I have to check is as luggage when I fly.
My dick is so big, you can't blow me without a ladder.
My dick is so big, Stephen Hawking has a theory about it.
My dick is so big, it's illegal to fuck me without protective gear.
My dick is so big, I can never sit in the front row.
My dick is so big, Las Vegas Casinoes fly it in for free.
My dick is so big, that when it's Eastern Standard Time at the tip, it's Central Mountain Time at me balls.
My dick is so big, that right now it's in the other room fixing us drinks.

Quick! Somebody call a Medic!
He's having a seisure!

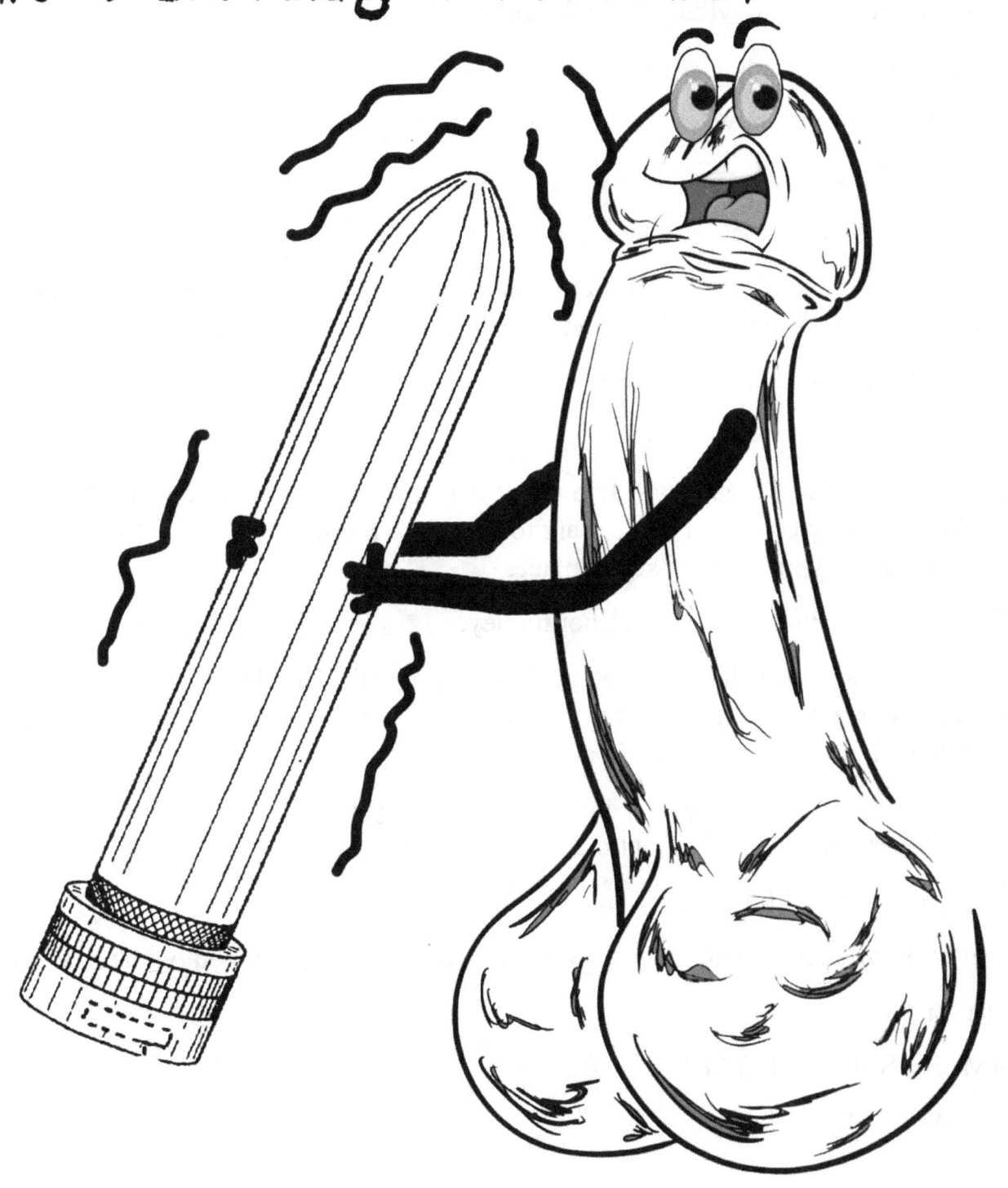

THE PENIS PRAYER

Today, I pray, for a penis of my own, to have and to hold, til death do we part.

I pray for a penis that will be mine for all time.

Today, I make an appeal to the god of phallus, 'send a penis to me'.

A penis that knows how to tease me and please me.

A penis who knows my needs and my desires.

A penis that knows just what to do to bring me to ecstasy.

And I promise that I'll never let it go. I'll never hurt it nor mistreat it, I'll protect it with my life. When it's feeling soft and weak, I'll make it hard and strong. I'll do it no wrong.

This is not penis envy, to be a man is not my dream.

This is greed.

For I am a selfish woman and I know that if I ever do find that one penis that satisfies me in every way conceivable, I'd want to keep it to myself. I'd want to lock it in a cage and hide the key in my most secret place.

I'd never part with it, not for love nor money.

You see, I know the value of a good penis and I know the lengths women will go through to procure one. So while I pray for this penis, a penis made just for me, I also pray that no bitch will ever try to contest. Cause I WILL cut her!

So as I embark on another unpenisified day I pray that the god who rules over this magnificent specimen will grant me this one wish.

A big, thick, beautiful cock

(with my full name [in all CAPS, bold and double spaced] tattooed on the shaft)

just for me

AMEN / SELAH / SO MOTE IT BE

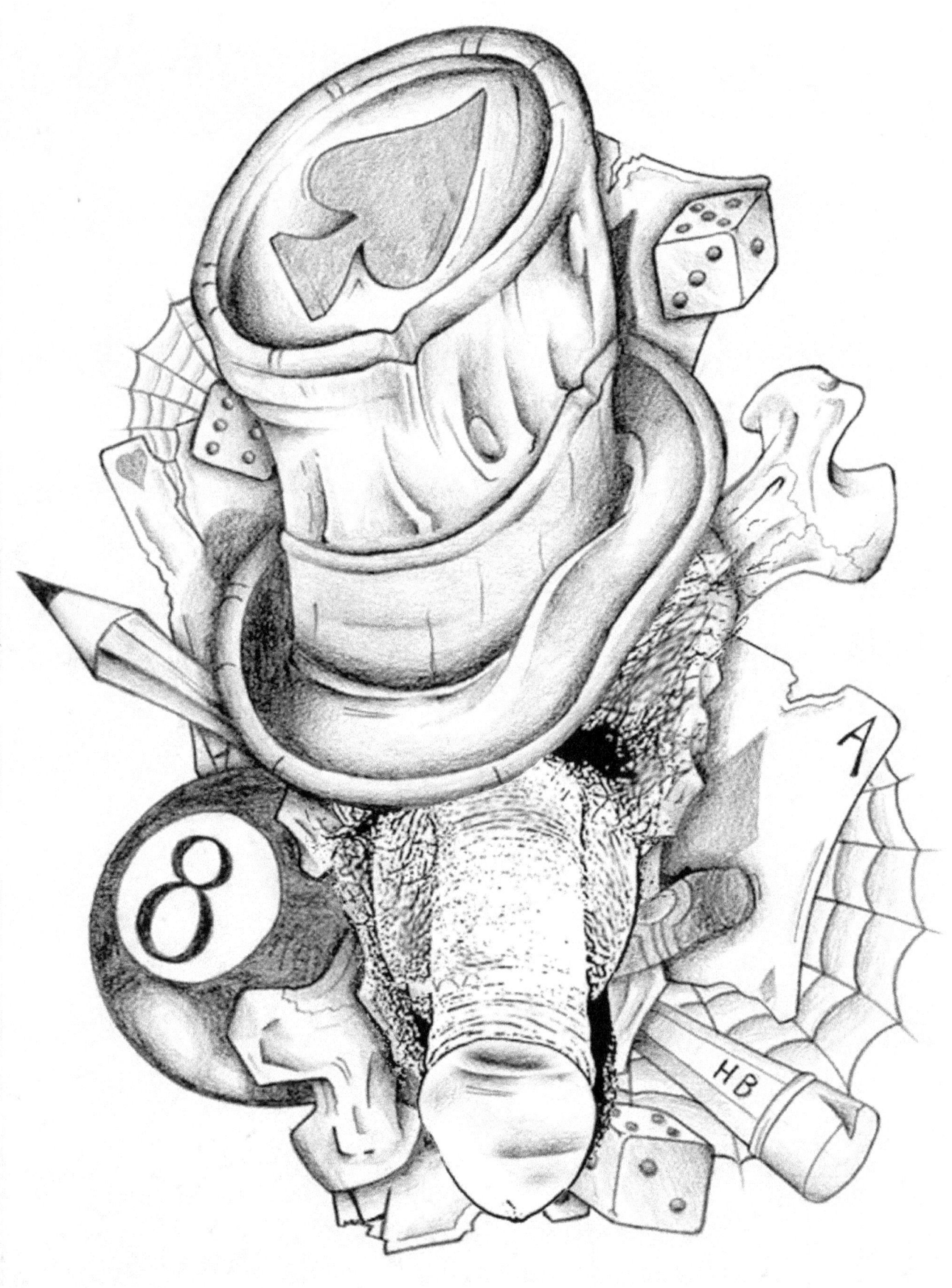

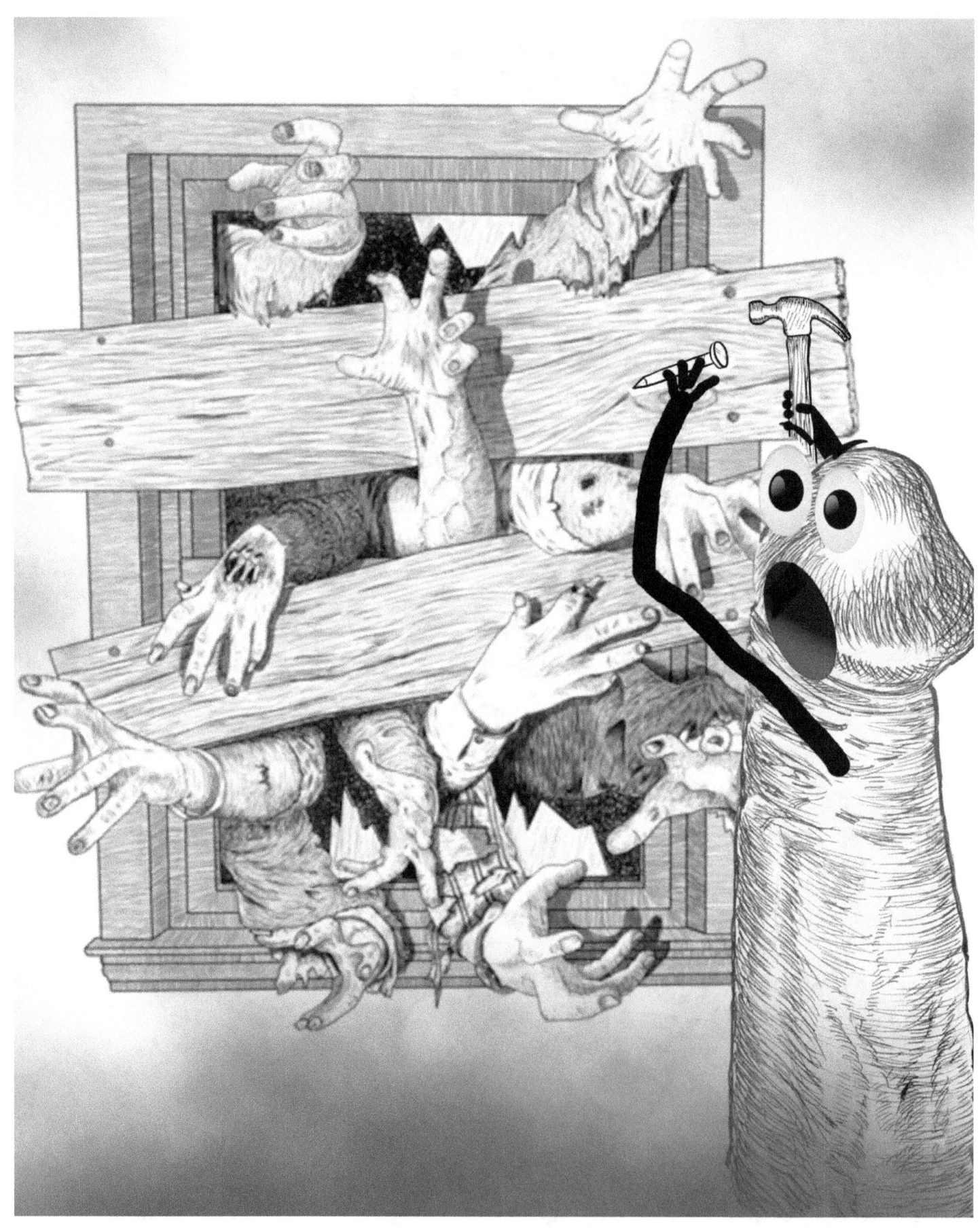

HUGH JORGAN STARS IN...

THE COCKING DEAD

THE PETER POEM

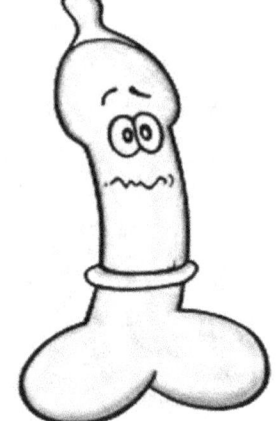

My nookie days are over,
My pilot light is out,
What used to be my sex appeal
is now my water spout!
Time was when, on its own,
from my trousers is would spring,
But now its just a full time job
to find the fucking thing!
It use to be embarrasing
the way it would behave,
For every single morning
it would stand & watch me shave!
Now as old age approaches,
it sure gives me the blues,
to see it hang its little head
& watch me tie my shoes!

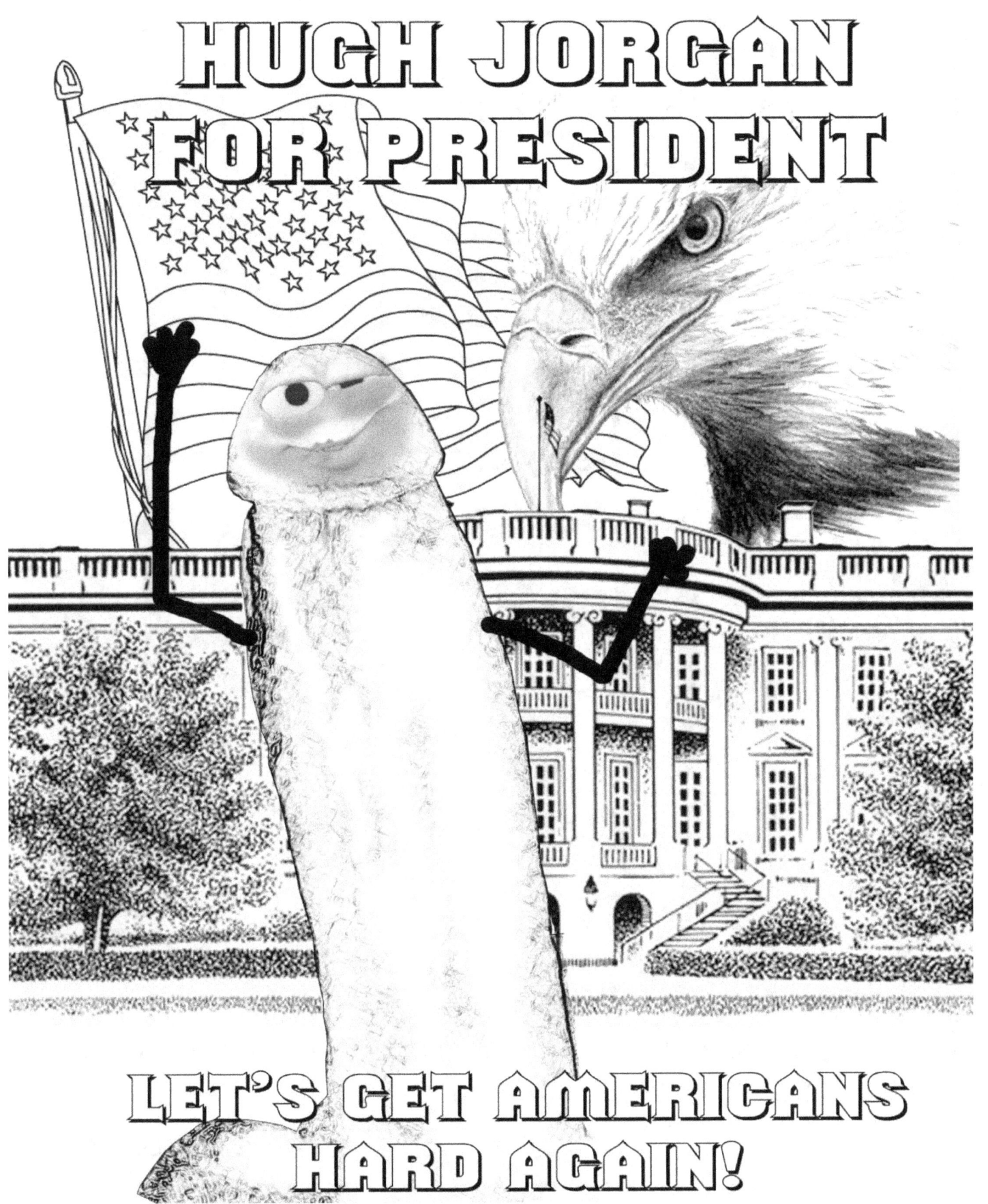

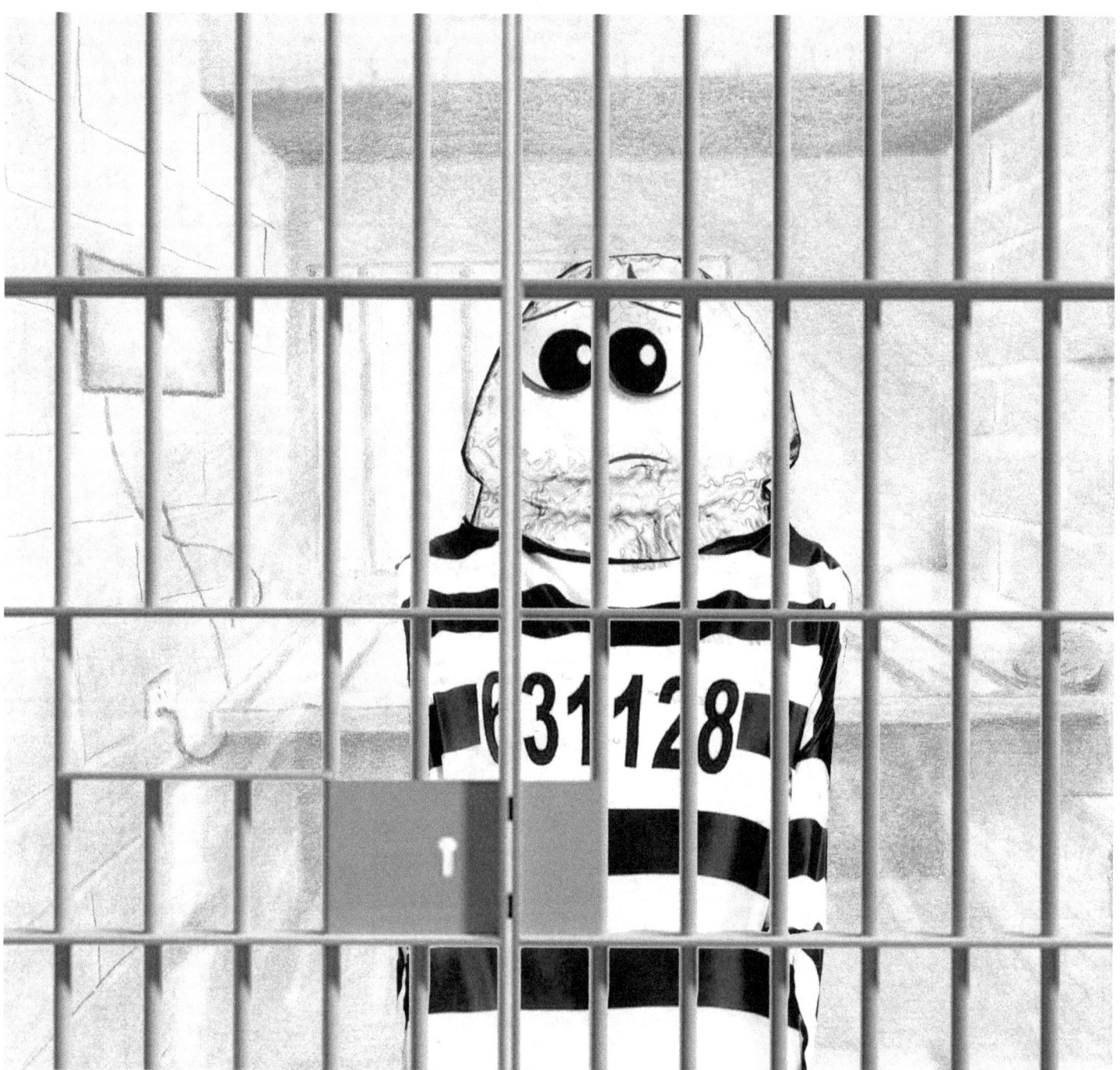

This concludes the adventures of Hugh Jorgan for now, as it seems he's gotten his peter in a bit of a pickle after getting arrested for lewd displays over at the White House. Until next time, happy coloring!

~ Rock Harding

ABOUT ROCK HARDING

Rock Harding, simply put, is just a good-hearted pervert. It's all in good fun for adults.

The color pages he creates are a combination of his own doodling, mad photoshop skills, and images purchased through various stock photo sites.

The images models for Hugh Jordan are sketches by Rock himself or relief images of his actual pecker or of his friend's, who agreed to help out in exchange for a case of beer and the scouts honour of anonymity. So sorry guy and gals, he can't hand out his number.

While Rock holds no expectations of any artist of the year award, he hopes you'll have some fun with his coloring books. Just remember, if the pages stick together, that's all on you. However, it's never harmful to say… pictures or it didn't happen.

"Stroke on!" ~Rock Harding

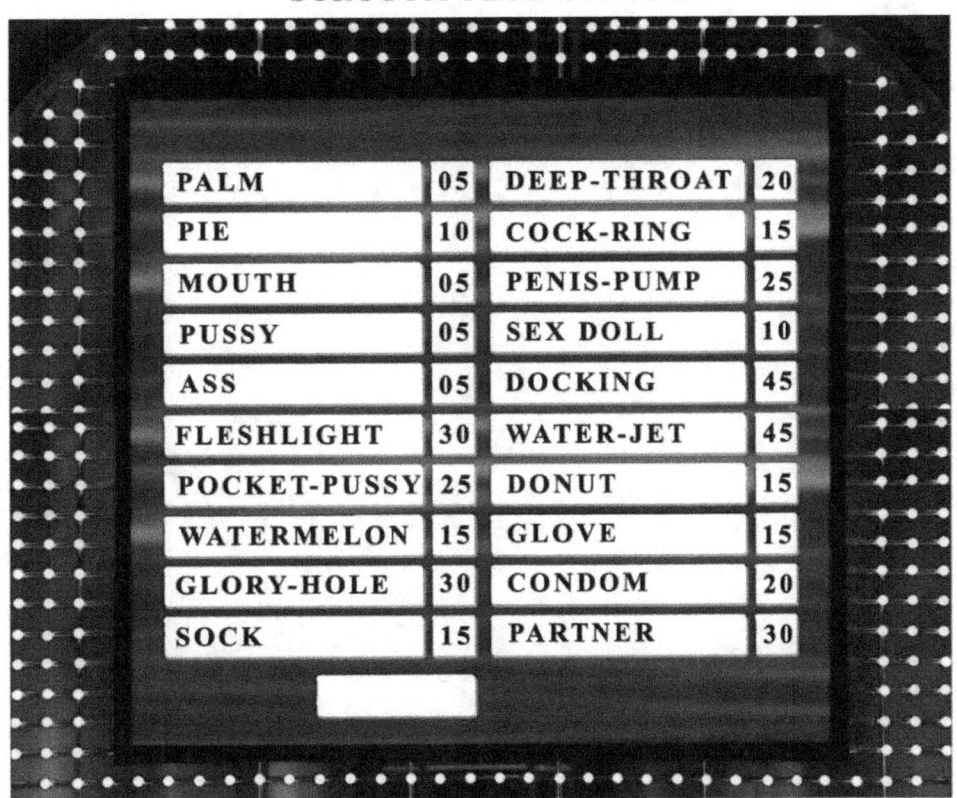

SCROTUM FEUD ANSWERS

PALM	05	DEEP-THROAT	20
PIE	10	COCK-RING	15
MOUTH	05	PENIS-PUMP	25
PUSSY	05	SEX DOLL	10
ASS	05	DOCKING	45
FLESHLIGHT	30	WATER-JET	45
POCKET-PUSSY	25	DONUT	15
WATERMELON	15	GLOVE	15
GLORY-HOLE	30	CONDOM	20
SOCK	15	PARTNER	30

RIDDLE ME DIDDLE & FINGER ME PICKLE

WHAT DO YOU GET WHEN YOU BRING FIVE COUNTRY LEADERS TOGETHER AND THE PARTY FAVORS ARE SPANISH FLY AND VIAGRA?

(EVERYONE GETS A SCHLONG)

WHAT TYPE OF DICK CAN COMMUTE WITH GHOSTS?

(A MEDIUM DICK)

WHAT IS THE INSENSITIVE BIT AT THE BASE OF THE PECKER CALLED?

(THE MAN)

WHY DOES A PENIS HAVE A HOLE IN THE END?

(SO GUYS CAN BE OPEN-MINDED)

WHAT DOES A PERVERTED PARROT SAY?

(POLLY WANT A RIM JOB?)

WHAT DO YOU GET WHEN YOU CROSS A PICKLE WITH A DEER?

(A DILDOE)

www.ingramcontent.com/pod-product-compliance
Lightning Source LLC
Chambersburg PA
CBHW080821170526
45158CB00009B/2489